INVENTING THE LANDSCAPE

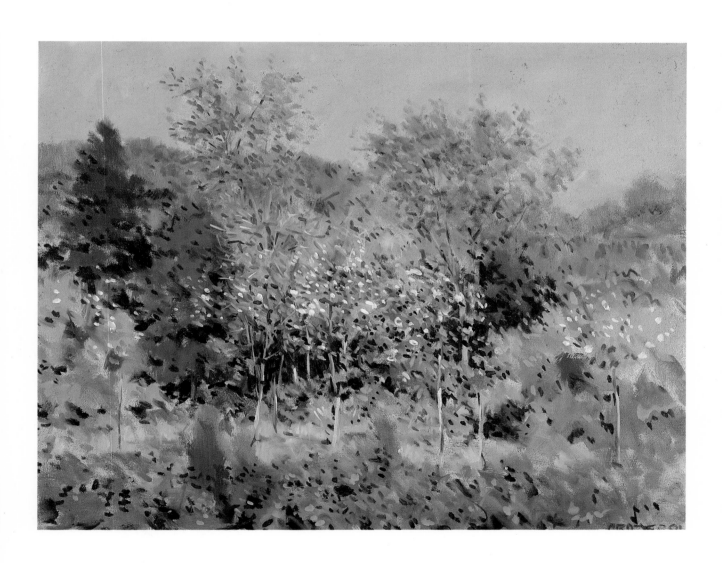

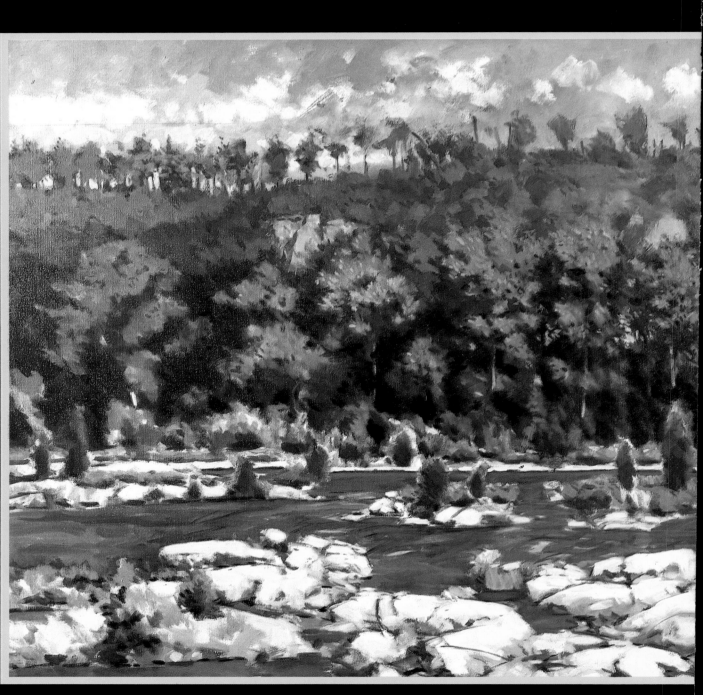

INVENTING
THE
LANDSCAPE

From plein air study
to studio painting

RICHARD CROZIER
with THOMAS BOLT

WATSON-GUPTILL PUBLICATIONS/NEW YORK

Art for frontispiece:
START OF SPRING,
1981, oil on canvas,
14″ x 18″ (35.6 x 45.7 cm)

Art for title page:
MAURY RIVER,
BATH COUNTY, VIRGINIA,
1984, oil on canvas,
40″ x 60″ (101.6 x 152.4 cm)

Copyright © 1989 Richard Crozier with Thomas Bolt

First published in 1989 in New York by Watson-Guptill Publications,
a division of Billboard Publications, Inc.,
1515 Broadway, New York, N.Y. 10036

Library of Congress Cataloging-in-Publication Data
Crozier, Richard.
 Inventing the landscape: from plein air study to studio painting
 Richard Crozier with Thomas Bolt.
 Includes index.
 ISBN 0-8230-2547-0: $27.50
 1. Landscape painting—Technique. I. Bolt, Thomas, 1959–
II. Title.
ND1342.C76 1989
751.45′436—dc19 88-31342
 CIP

Distributed in the United Kingdom by Phaidon Press Ltd.,
Littlegate House, St. Ebbe's St., Oxford

Manufactured in Japan

First printing, 1989

1 2 3 4 5 6 7 8 9 10/93 92 91 90 89

Edited by Candace Raney and Lanie Lee
Designed by Areta Buk
Graphic production by Hector Campbell

to Marjorie

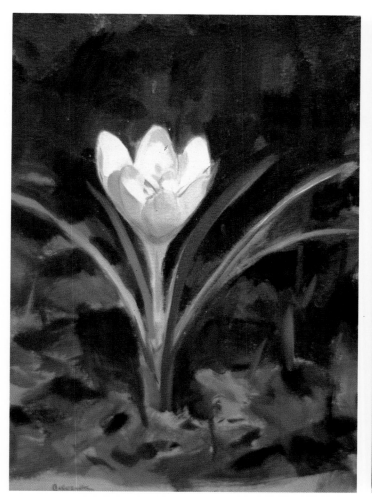

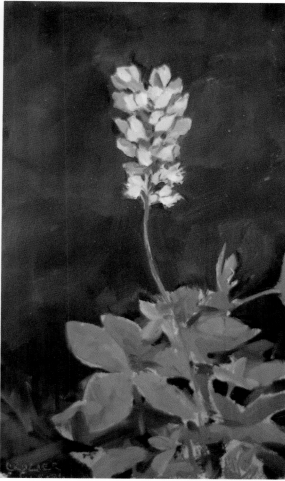

WHITE CROCUS
1985, oil on rag board
8″ x 5¾″ (20.3 x 14.6 cm)

FALSE LUPINE
1985, oil on rag board
10″ x 5¾″ (25.4 x 14.6 cm)

**THE MADRONA TREE
IN THE QUAD**
1968, oil on canvas
14″ x 16″ (35.6 x 40.6 cm)

CONTENTS

INTRODUCTION

Richard Crozier's landscapes range from small studies of flowers, executed with an offhand skill, to large panoramic triptychs. Between these extremes Crozier has produced a solid body of work in which painting outside, and regularly testing memory against observation, is as much an ongoing discipline as an aesthetic.

Crozier has painted throughout the United States: from his recent work along the Maine seacoast, to Hawaii, where he grew up, to northern California, where he earned a M.F.A. degree at the University of California, Davis. Although he has painted in West Virginia, Michigan, Arizona, Washington, Wyoming, Maine, Massachusetts, and New York, Crozier's abiding subject is the Blue Ridge Mountain country of central Virginia, where he lives and teaches at the University of Virginia in Charlottesville.

In the catalog to the exhibition Contemporary American Realism Since 1960, curator Frank Goodyear quoted Crozier's wish "to work with the unremarkable, familiar, anonymous landscape that one might see briefly out of the corner of one's eye from a freeway." The same sensibility that led Crozier to what was considered underrated and ordinary in the landscape (often so "ordinary" that we don't notice it ourselves until we see it in one of his paintings) has also led him to dare to paint subjects we might disdain because they have grown hackneyed and conventionalized over the years. Crozier is a painter to whom nothing is off-limits. Luckily for us, Crozier's vision can comprehend daffodils and sunsets as well as 55-gallon trash burners and construction excavations. Just as a sentimental, conventional painter will produce sentimental, conventional paintings whatever the subject matter, a thoughtful, sensitive painter can paint anything.

The power of Crozier's plein air paintings comes from their immediacy and freshness. His approach is simple enough to state: looking and painting. Even with his largest paintings, which are invented in the studio, his approach is fundamentally painterly: fluid, at ease, and concerned with the sensory look *of* things rather than the conceptual ideas *about* things. These paintings function as dialogues between the painter's memory and his imagination.

Not everyone is aware of the creativity involved in painting outside, from observation. But remember, the eye is not a camera: it does not record; it processes information, continually. So thinking is always a part of seeing. At the very least, the brain selects which part of what is seen we will be aware of, and what information is of no use to us. There is so much information in even the simplest landscape, that when you begin to paint, you move immediately from pure perception into selection. It is in this highly selective filtering of what is seen into what we will see in the finished painting, that Crozier so excels. There is no unnecessary detail in a Crozier painting: all is stripped to the barest optical sense.

A painter of perception is also concerned with emotion, because our surroundings always affect our emotions. Imagine yourself, for instance, in the North Labrador of the poet Hart Crane. As the extreme barrenness of the desolate northern landscape produces a definite emotional affect, so does the local weather of Virginia, in its own way really no less spectacular. A change of surroundings is a change of meaning. We find meaning in our surroundings because our surroundings influence us in so many ways. A good landscape painting can concentrate these feelings into a coherent emotion. A landscape is, as Gustave Courbet and Peter Paul Rubens and Albert Pinkham Ryder must have known, a psychological subject as subtle and as complex as a portrait.

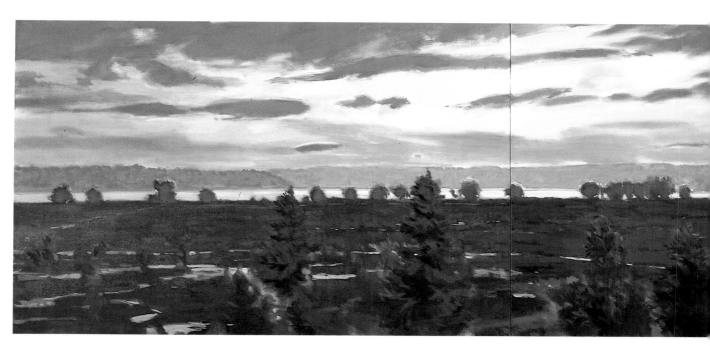

Landscape painting is the most abstract of the conventional genres of art. The abstract expressionist painters of the 1950s liked to describe their paintings as landscapes. In fact, I once glanced at an author's photograph on a book jacket and assumed that he had been posed against a steep hillside covered with dead leaves; on closer examination, I realized the background was Jackson Pollock's painting *Autumn Rhythms*.

Some of Richard Crozier's important influences, as an undergraduate at the University of Washington in Seattle and later on at Davis, were the pioneers of the Bay-Area figurative group, Elmer Bischoff, David Park, and Richard Diebenkorn, all originally abstract painters. At Davis, Crozier studied with Wayne Thiebaud, whose influence can be seen in the angled shadows and brilliant, overstated light of Crozier's paintings of the 1970s. As a burgeoning landscape painter, Crozier must have felt himself in a distinct minority among art students. In those times of abstract ascendancy, a student was not encouraged to work representationally. A student asking for advice about a landscape might be advised by a professor (as in fact happened) that what the painting really needed was a thin red stripe running down the left-hand side of the canvas.

Instead of rebelling against brilliant—if sometimes less than logical—teachers like the cosmic doodler William T. Wiley, Crozier learned what he could from them and continued to paint the way he wanted to. Yet his work continues to show the influence of the San Francisco figurative painters, as well as a pronounced Zen quality that must have been acquired, or at least strengthened, in California.

When Crozier moved to Charlottesville in 1974 to teach at the University of Virginia, it marked the beginning of one of the most productive periods of his career. He felt an unusual affinity for the Virginia landscape: maybe the tall field pines, with their branches bunched at the top, reminded him of the Hawaiian palm trees (though they look much less like palms in life than they do in the paintings). Five years later, his first one-man show, at the Tatistcheff Gallery in New York City, was reviewed in *The New York Times* by art critic Hilton Kramer, who praised the "distinct poetry" of Crozier's work.

Today there are four kinds of painting Crozier is concerned with making: the plein air painting, with the necessarily smaller format treated not just as a studio painter's study but as an important category of its own, sometimes modest, sometimes grand; the large invented painting; and a series of small, usually life-sized paintings of wild and cultivated flowers. The emerging fourth category combines the best features of the other three and also finds room for the human figure, not just as a narrative subject, but as an inhabitor, an organic part of the landscape.

Crozier's paintings treat, as a major theme, our necessary interrelatedness with the landscape. Sometimes this relationship is peaceful and hopeful, as in a recent painting of the artist's wife gardening. Other paintings bear explicit witness to our lack of regard for our surroundings, and set forth such unsentimental themes as burned-out lots, devastated areas, abandoned construction sites, and dumps. It is a testimony to Crozier's tactful skill as a painter that he can paint a weedy lot as beautifully as a bed of irises. There is little rhetoric to his work; this painter deals in proofs, not polemics. Even when he is doing something more than constructing a beautiful painting, he knows how to be quiet and let the evidence speak. His paintings are as self-assured in what they give us—and as unassuming—as the eye itself.

Thomas Bolt
New York City, 1988

SAINT GEORGE'S RIVER
1987, oil on canvas, diptych
48" x 120" (121.9 x 304.8 cm)

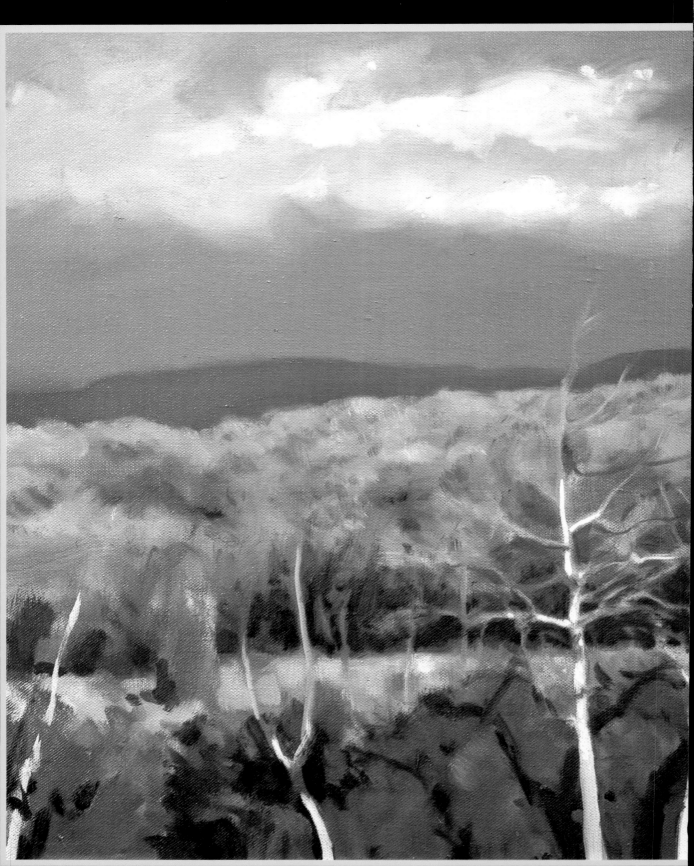

I. PAINTING OUTSIDE

STORM LIGHT
1982, oil on canvas
14" x 18" (35.6 x 45.7 cm)
Collection of G. Remak Ramsey

PLEIN AIR PAINTING

The act of painting forces you to look, and fixes information in your mind: if you can paint it, you can retain it. Even when the light moves and the whole structure of what you see changes, the moment has passed, but you still have the information.

My working time on a plein air painting is usually about two hours. I have difficulty concentrating on a motif for more than two hours at a time: after that, I find I'm simply looking at the painting itself, which I might as well be doing in the studio and not out in the field. What I want to do, then, is get a direct and fresh impression of the landscape, and get an entire painting down on canvas, without getting too bogged down in details. If need be, a painting with enough general information can be finished, reworked, or cleaned up in the studio. Often, two hours is plenty of time to paint a finished painting.

It's important to realize the difference between what your eyes actually see, and what you know—or think you know—about what you're seeing. As a teacher, I've found that to be one of the great hurdles: people tend to conceptualize, and to favor conceptualization over the visual discipline of drawing what they actually see. In my own work, I try to be careful not to let this happen. I treat what I see as general optical information—contour, patterning, value, and tonality—instead of looking at specific, individual things like stones, twigs, leaves, or limbs.

When painting outside, I also try to keep myself from getting too involved in things that aren't really important to the painting. As an experienced painter outdoors, you get to know what you can do later, back in the studio, and what you have to do on the spot.

It's always best to begin by getting down the major contours of the land, the shape of the hills, the foliage, and all the larger forms, treating the landscape as you might a table-top still life. To do this, I look for light, color, and value. I find an average color and then try to work in the suggestion of warm and cool colors, and darks and lights. I don't worry about whether I'm looking at plants or rocks, or specific tree textures, or even what kind of trees they are; I'm interested in the color of the shapes, their sizes, and last of all, if there's time, their textures. In observational paintings like mine, complexity is suggested by texture. Textures stand in for the details that are too complex for the eye to assimilate all at once. After the important forms and tonal relationships have been established, just a suggestion of the textures of things will transmit that very complex information.

I don't consciously compose these plein air paintings, because what I'm really after is information. I think the potential for composition is sufficiently ingrained in me, whether I'm consciously looking for it or not. The main thing to remember is to force yourself to simplify. When you're outside painting, there's so much going on that even the dullest roadside field can provide a potentially infinite amount of information. You have to begin by being very selective.

GLADDEN FIELDS
1982, oil on canvas
16" x 24" (40.6 x 61.0 cm)

I painted this on a small farm that sold produce, south of Charlottesville. I asked the owners if I could paint there, and they were pleased to let me do it. This is larger than my usual on-site paintings, but I think it came out pretty well.

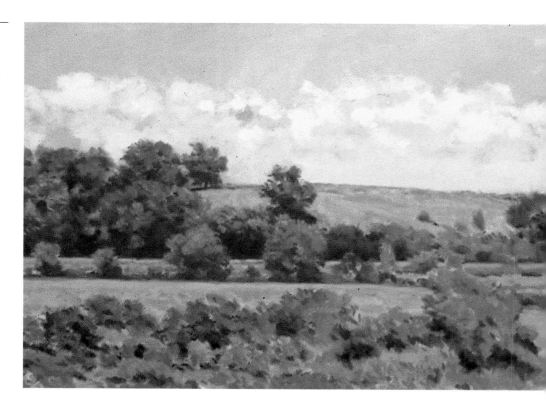

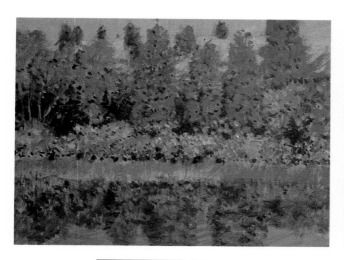

REFLECTIONS
BEAVER DAM LAKE
1976, oil on rag board
14" x 18" (35.6 x 45.7 cm)

In this painting I was interested in the reflectivity of the lake—the difference between a subject and its reflection.

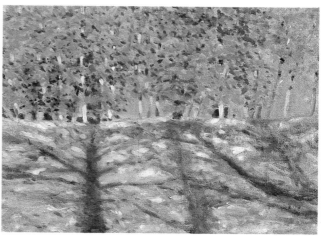

CARR'S HILL
1976, oil on canvas
14" x 18" (35.6 x 45.7 cm)

Sometimes the simplest motifs are the most interesting. Here, for instance, the way the shadows of the trees seem to loom out of the slope, and the bright orange color of the trees seen over the crest of the hill help to define the slope.

CATTAILS
1979, oil on canvas
12" x 18" (30.5 x 45.7 cm)

Here, I was interested in the mark the cattails (which were well past their prime) made in the landscape. The rhythmic movement through the lower part of the painting is articulated by the various shapes that the white parts of the decaying cattails made. I was also looking carefully at the textures and colors of the railroad embankment. This painting is as true to the actual site as I could make it.

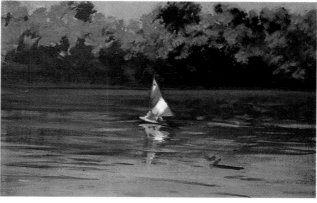

SAILBOAT,
BEAVER DAM LAKE
1978, oil on canvas
12" x 18" (30.5 x 45.7 cm)

I really liked the dense, deep colors on the reflective surface of the water. The little boat with the striped sail was just a nice accident in the landscape. Obviously it wouldn't hold still for me, so I had to get it down quickly. First, I concentrated on the sail, and then I indicated the boat beneath it. I was thinking at the time of the work of Wayne Thiebaud: it seemed to be a motif he would have been drawn to, although he would have simplified the whole picture much more than I did.

BARE SYCAMORE
1977, oil on canvas
12" x 16" (30.5 x 40.6 cm)
Collection of Severson

I've done a number of paintings of sycamores, because I find them gestural and dramatic: they tend to stand out in the landscape. The middle ground is divided by the trees' shadows, which also help to define the ground behind them.

RED CEDAR
1976, oil on canvas
12" x 14" (30.5 x 35.6 cm)

I was very satisfied with this painting, because it was here that I felt I could finally paint a convincing cedar tree. I had found the right solidity to its mass, and the proper tonality.

EDGE OF THE LOT
1977, oil on canvas
14" x 18" (35.6 x 45.7 cm)

Ailanthus trees look something like palm trees to me, although they're a very different plant. The disruption the ailanthus set off against the usual foliage seemed a good enough excuse to do a painting. This may seem to be a very minor event, but it's one that would interest a painter.

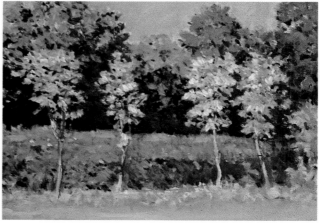

YOUNG OAKS
1977, oil on canvas
14" x 18" (35.6 x 45.7 cm)

What drew my attention to this scene was the way the line of small trees near the road made a grid against a background of larger trees.

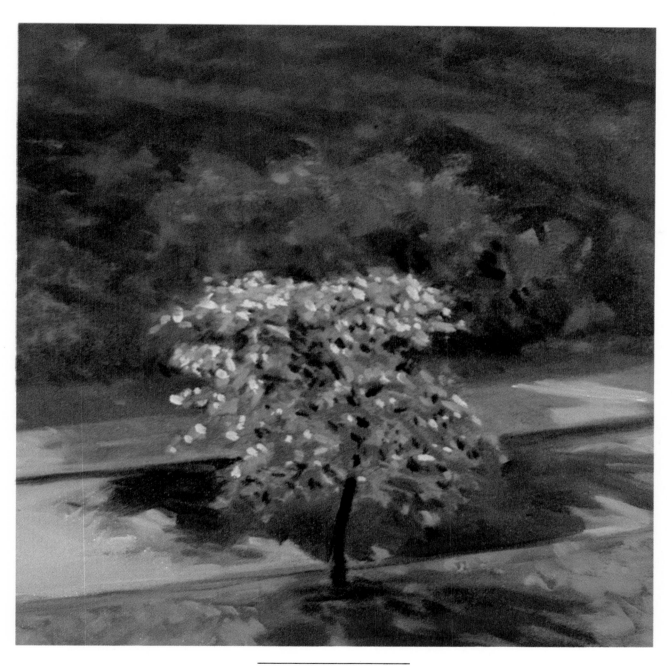

DOGWOOD IN SUN
1976, oil on canvas
12" x 12" (30.5 x 30.5 cm)

Looking down at this small flowering tree, I was trying to understand its anatomy, and how it related to the space it inhabited.

CARTER MOUNTAIN
1982, oil on canvas
14" x 16" (35.6 x 40.6 cm)

This was painted from very high up, over the landscape; I was looking back toward a mountain. In this case, I wanted a fairly specific, identifiable scene, rather than an anonymous view.

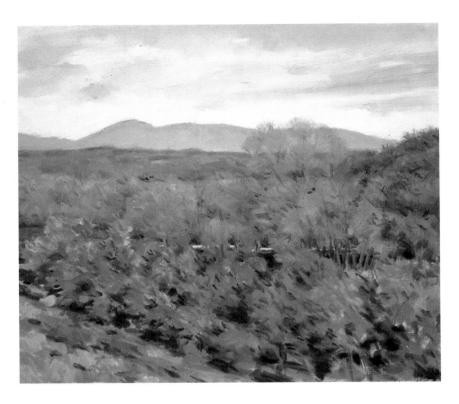

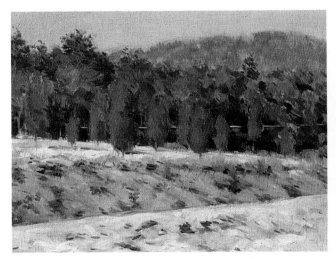

NEAR NORTH GARDEN
1982, oil on canvas
14" x 18" (35.6 x 45.7 cm)

Landscapes are too often painted in head-on views. In the contours and diagonal forms of this site, I found a strong sense of geometry. The usual concerns of light, color, and texture are present, but there is also a compositional statement that makes the painting more interesting.

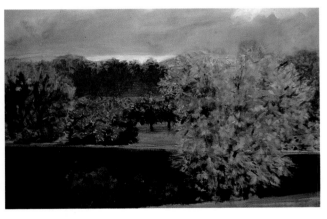

NORTH FROM THE GROUNDS
1975, oil on canvas
12" x 18" (30.5 x 45.7 cm)

In this view I was looking out over the railroad embankments near the University of Virginia rugby fields. I used a series of diagonals in the foreground to work back into the background, and then I modulated them with trees receding into the background of a very gray, atmospheric day. My main focus here was on the spatial recession of the landscape to the horizon line.

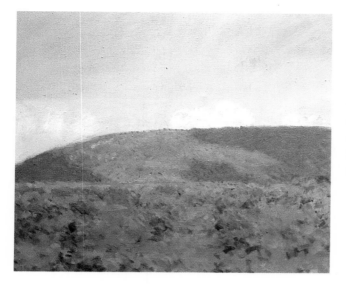

PINEY MOUNTAIN
1977, oil on canvas
16" x 18" (40.6 x 45.7 cm)

In this painting you see the shadows of clouds cast on the mountain, but the clouds themselves aren't visible because they are outside the frame of the picture. These clouds, which you have to imagine, extend the landscape beyond what you can actually see: you have a feeling of life going on outside and far above the painting. Those shadows, which were largely invented, also serve to organize the picture.

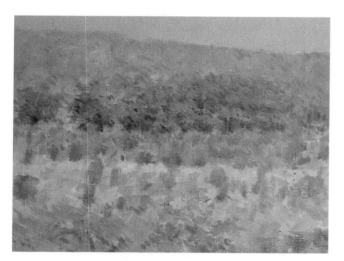

EARLY SPRING, ROCKFISH VALLEY
1978, oil on canvas
14" x 18" (35.6 x 45.7 cm)

To paint this I looked up the side of a mountain, at shaved-off land where vegetation was starting to come back up—little pine trees, high grass, and cedars. I had a clear view up a bank of pine trees and a mountain slope behind it. I was trying to understand the way the mountainscape divided into bands, layers, and textures, and how the atmosphere modulated all of that as I looked back into space.

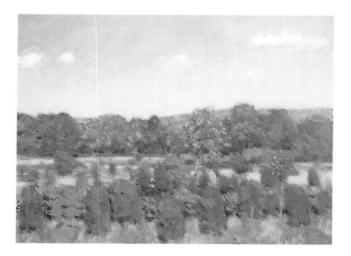

MEADOW NEAR SCOTTSVILLE
1980, oil on canvas
14" x 18" (35.6 x 45.7 cm)

Here, I was trying to pick out the different colors of the scrubby growth in the foreground, and trying to work them into the distant background through the recession of size and the diminution of texture.

THE FAMILIAR AND THE UNFAMILIAR LANDSCAPE

Looking carefully can make even the most familiar site strange and new. I feel a real sense of discovery if I can bring out some interesting quality hidden in a more-or-less ordinary landscape, something that may be overlooked by many people on a daily basis. To a good observational painter—and a persistent observer—nothing, really, is ordinary.

One way of picking out the extraordinary is to look at a site in a slightly different way. Something as familiar as a roadside field you drive past every day for years can become quite another thing if you look at it carefully. Think of the geography of the site: how it blocks or reveals distances; the space from object to object; the color that the atmosphere makes the light; and the always-changing plant life.

Generally, I avoid the picturesque, the ready-made painting. If I've treated a motif many times, I tend to avoid it unless I can see that motif in a new way or there's specific information that I want. Otherwise there won't be any excitement in painting it again.

STADIUM PARKING LOT
1977, oil on canvas
14" x 18" (35.6 x 45.7 cm)

This is a site on the extended grounds of the University of Virginia that has changed radically. There are buildings there now. The site was a big, ratty gravel parking lot with a slope and some locust trees that were there as if by accident. Rising up at an angle out of the slope, the trees cast shadows that define the space in the painting. The coolness of the light really made the trees stand out. This painting is a study in contrasts between the planes—the parking lot, the slope behind, and the trees rising out of the slope.

BEHIND ROY'S
1982, oil on canvas
14" x 18" (35.6 x 45.7 cm)

In this scene I was looking at the way the light fell on the snow-covered plowed furrows, and a slope covered with pines. This painting was done on my last trip through this area (after construction started I stopped going). I painted it from the parking lot behind a fast-food restaurant that had already been built on the site. The "Roy" in the title is Roy Rogers.

SNOW, STUDIO YARD
1982, oil on canvas
14" x 18" (35.6 x 45.7 cm)

This is a carefully observed study of snow, bushes, and a sycamore tree. I was interested in the complexity of the composition set up by the branches of the trees, the snow seen through them, and the brightness and contrast of the shadows. This painting probably took about an hour and a half to paint—one doesn't want to take too long out in the snow.

**SUNSET,
LEWIS MOUNTAIN**
1975, oil on canvas
14" x 18" (35.6 x 45.7 cm)

Lewis Mountain can be seen from the University of Virginia grounds, and it's a very distinctive feature in the nearby landscape. I would often paint it from there late in the afternoon, after I had finished teaching. Since the mountain is due west, at that time of day the sun goes down behind it or close behind it. It's a very dramatic, atmospheric view, and something you can't help but feel. The darkness and the pressure of the atmosphere surround you, so you become a participant in the scene. Painting sunsets is a risky business, but not the sort of risk I think a painter has to avoid.

**CREPE MYRTLES,
STADIUM ROAD**
1975, oil on canvas
18" x 20" (45.7 x 50.8 cm)

This was a traffic island, seen against a mass of foliage. I was interested in the flatness of the small cultivated area with the bare trees.

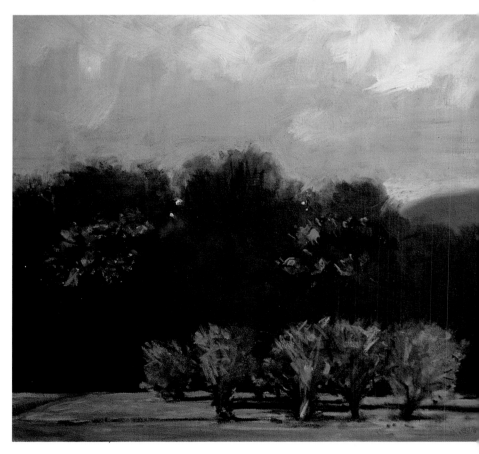

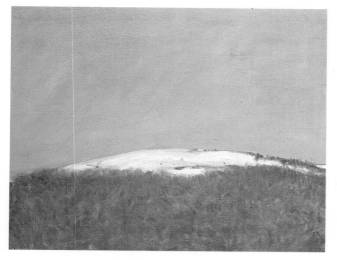

BROWN'S MOUNTAIN
1976, oil on canvas
14" x 18" (35.6 x 45.7 cm)

This was painted one winter after a particularly heavy snow. We were snowed in, and I painted this from the window of the art building at the University of Virginia. I could barely see the top of the mountain from there, but it was interesting because the snow was lighter than the sky. Since the mountain was just a tiny piece of the landscape, seen from there, I had to isolate it.

It reminded me of a story about Gustave Courbet out painting: someone saw him out in the woods painting a landscape that didn't look like anything in the vicinity. When the fellow asked him what he was painting, Courbet said, "Look through those trees, you see that little spot up there?" There was a tiny bit of landscape he had picked out to paint. That's what this painting was like to me, just picking something out.

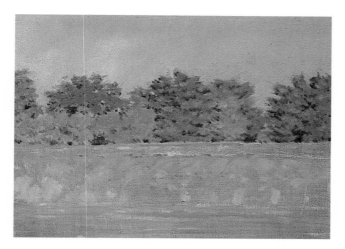

RED CLAY, LANNIGAN FIELD
1977, oil on canvas
14" x 18" (35.6 x 45.7 cm)

This eroded hillside is part of a playing field where grass has never grown in (probably because it's too steep, and the soil is too coarse to sustain grass). The spots where the red Virginia soil shows through have always interested me.

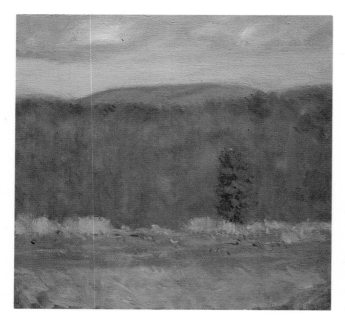

MOUNTAIN ROAD
1976, oil on canvas
16" x 18" (40.6 x 45.7 cm)

I don't remember exactly where this was, but I do remember the place—high up in the hills, with a view over bare trees covering mountains. It was a raw, cold day, and I had driven up a dirt road—a logging road or even a fire road in the mountains. I painted this looking out toward distant shadowy mountains. Often I don't even know where I am when I'm painting. I've usually ended up at a site by chance, by turning up some road chosen at random.

WEST FROM THE PARKWAY
1976, oil on canvas
16″ x 18″ (40.6 x 45.7 cm)

Here, I was looking off the side of the Blue Ridge Parkway at fairly unspoiled landscape, with the Shenandoah Valley in the far distance.

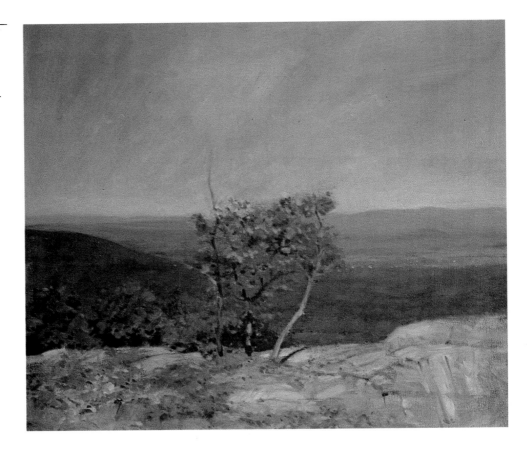

AT MINT SPRINGS
1979, oil on canvas
14″ x 16″ (35.6 x 40.6 cm)

I was not really looking at the lake—which is the focal point of the landscape at Mint Springs—but at this almost preposterous tree. It made an axis just to one side of dead center in the picture. The tall, thin tree trunk sticking up felt extremely arbitrary, and I liked that.

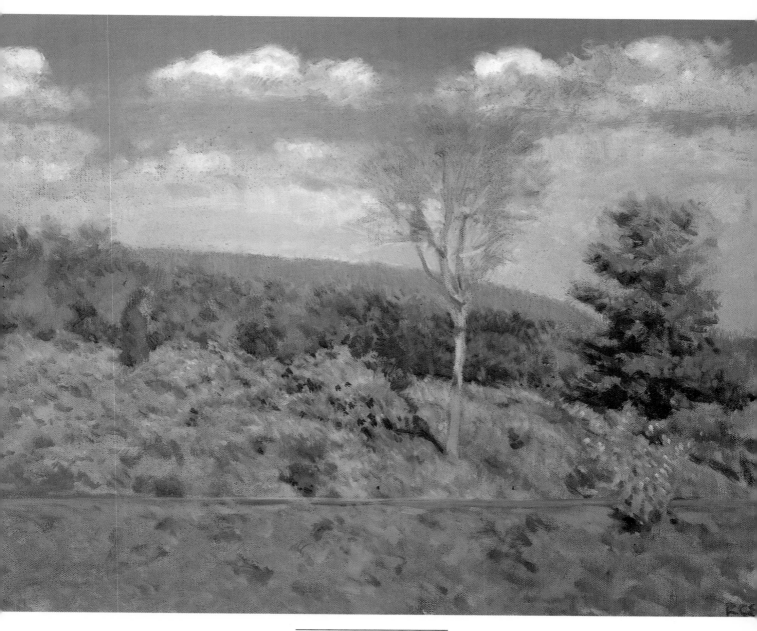

FORSYTHIA
1982, oil on canvas
14" x 18" (35.6 x 45.7 cm)

The bank of unexpected color in the landscape, the brilliant yellow flowers, was what inspired me to make this painting.

CLOUDS AND TREES
1975, oil on canvas
12" x 18" (30.5 x 45.7 cm)

Here, I liked the way the mass of trees and the clouds that were forming behind them had the same sorts of shapes. I wasn't all that concerned with the phenomenon as a formalistic problem: it just felt nice. Trees seen just as mass and texture are exciting to look at. By looking over the tops of trees, where there is light, space, and air, you can see the solidity of the trees and the way they catch the light. It's a simple thing, but something I find difficult to paint well, and visually exciting. It's also an anonymous type of landscape, and the more anonymous the motif, the more the artist has to put himself or herself into it.

AT PEN PARK
1981, oil on Masonite
8" x 10" (20.3 x 25.4 cm)

This was a demonstration I did for a painting class. It has a diagonal structure—something racier than what I usually do; I was looking across a slope rather than facing it head on. An important feature of this site was the way the texture of the cedars played off against the texture of the deciduous trees behind them.

**SHADOWS, JEFFERSON
PARK AVENUE**
1977, oil on canvas
12" x 16" (30.5 x 40.6 cm)

This is one of a long series of paintings where I examined the different lights and shadows that were cast on a street. Some paintings were done from the porch and others from out the window. Sometimes it's best to work with whatever is found close to hand.

**RHODODENDRONS ON
SLOPE**
1977, oil on canvas
14" x 18" (35.6 x 45.7 cm)

Near MacIntyre Park in Charlottesville, I was looking across a highway where the city had planted a lot of rhododendrons. Looking at the shadows cast by the plants and by the things behind them, I was trying to define the planes of the hill.

TOWARD JEFFERSON PARK
1977, oil on canvas
14" x 16" (35.6 x 40.6 cm)

This was done from the porch of an apartment I lived in, looking out over a little scrap of the parking lot. Oddly enough, it looks almost as if you're looking through a forest or in a lake. The road, being rather dark, could almost pass for water (one of the great curses on me has been that I paint water like asphalt and asphalt like water).

The sunlight was streaming down on the little ailanthus plant which was sticking up, asserting itself in the landscape. I was interested in looking through a screen of foliage at something in back and beyond, where you might not ordinarily look. I did a number of paintings of this same scene.

KUDZU VINES
1977, oil on canvas
18" x 12" (45.7 x 30.5 cm)

A vertical format is rare in landscape painting, but I like to use it occasionally for a change. Here, I was looking up into trees hung with kudzu vines—so much so that there was almost a bank of kudzu in the foreground. It was a bright, sunny day, with light reflecting off the trees. I'm interested in kudzu because it's an obvious feature in the southeastern landscape. It shrouds trees and transforms them into very different shapes.

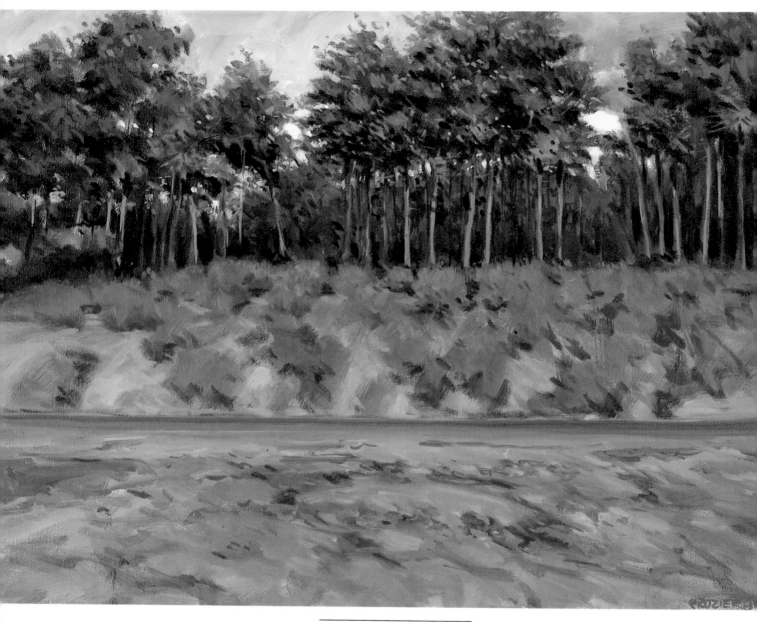

OLD ROAD
1981, oil on canvas
14" x 18" (35.6 x 45.7 cm)

Color, texture, and changes in plane or contour have been familiar concerns in my small paintings. This painting was reworked in the studio. The reworking was mostly to strengthen it: to enhance the contrasts and to bring up the colors.

ACROSS THE TRACKS
1975, oil on canvas
12″ x 18″ (30.5 x 45.7 cm)

This railway embankment that I have painted so many times makes an odd, unexpected, and useful division between foreground and background. Since there is a ready-made barrier in the picture, you are forced to read back and forth—from the background to the foreground and back again—rather than simply following an easily-defined path into the space of the painting.

GLADIOLUS
1981, oil on canvas
14″ x 18″ (35.6 x 45.7 cm)

I used to go out to Pen Park in Charlottesville to paint the city gardens. I found a whole row of gladiolus, and they just stood out and demanded to be painted.

STRUCTURING PAINTINGS

Usually, I look for the things that have always interested me: painterly problems of texture, light, and color. When you begin to paint, however, the canvas has to be divided up in a specific way for there to be order in it—whether it's one you have in your mind from the outset, or one you let develop during the course of painting.

The artist brings a personal sense of order to the landscape. If the structure of a painting is interesting, I think it's because of that. In my paintings there's most often a rhythmic division of space. I usually break the painting up into sections and then divide them into smaller areas, which I subdivide into even smaller compartments. These patterns are found in nature, but they have to be picked out and isolated by the painter.

Some of my paintings are more consciously organized than others, and in these paintings the placement of things is more or less deliberate. All of the components may have existed at the site much as you see them in the painting, but certain elements may have been emphasized to make them play a more important role in the composition. Of course, as always, elements have been simplified or left out—a building, for instance, may have had windows in it that didn't make sense to me compositionally; a row of trees that confused the composition may have become bare ground. There are times when I may rearrange the configurations of clouds or hills, or alter the textures of a mountainside.

Often, a painting will demand a certain kind of organization, and I feel it's up to me to provide it, either by emphasizing existing elements, or eliminating things that seem superfluous. The important thing is that the composition should grow out of the suggestiveness of the site, not simply be imposed by the painter.

TREE SHADOWS
1977, oil on canvas
14" x 16" (35.6 x 40.6 cm)

This site is Carr's Hill at the University of Virginia. The grid of shadows strengthens the ground plane and almost holds it down; it also defines the distance between the viewer and the trees in the background. This oddly low point of view makes it seem as if you're sitting on the ground.

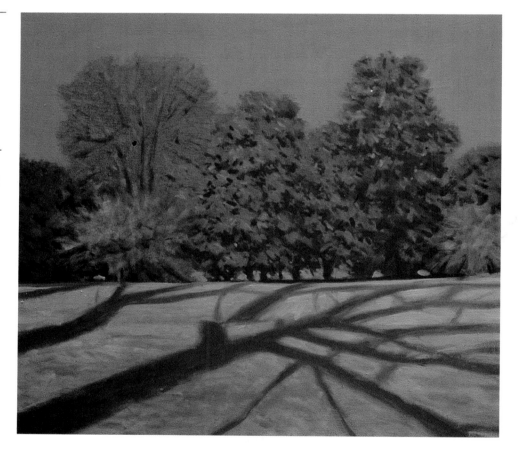

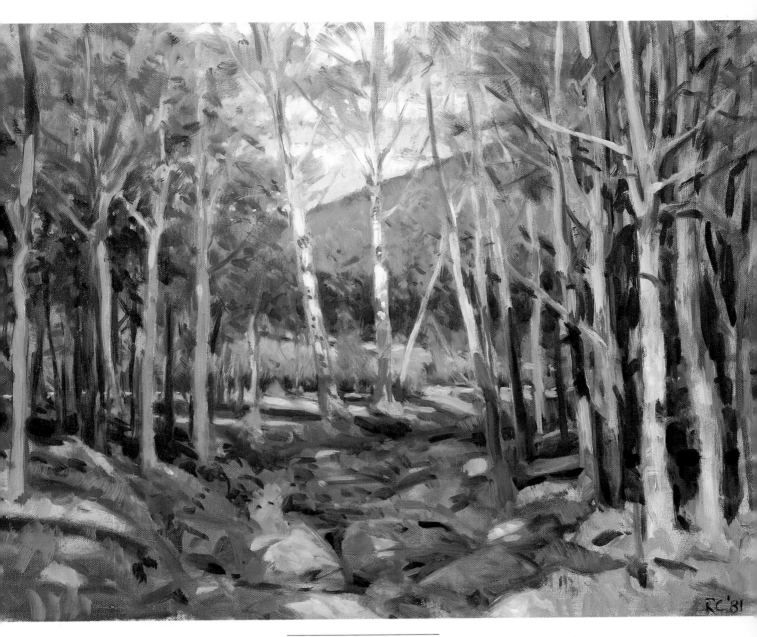

WOODS
1981, oil on canvas
14" x 18" (35.6 x 45.7 cm)

*This painting feels a little different for me in terms of organiza-
tion, because there's a distinct, direct path into the space of the
picture through the foreground—something I don't usually do.
There is also a verticality to the picture as well as the hint of a
horizon and a diagonal hill in the background. But the verticals
of the trees, running from top to bottom, carry the painting.*

DUDLEY MOUNTAIN
1981, oil on canvas
14" x 18" (35.6 x 45.7 cm)

I wasn't terribly happy with this when I painted it, but I feel better about it now. It was a fast painting; it took about twenty minutes to paint. One of the things that surprises me is how formally composed it is. There's a strong sense of composition: the diagonal of the ground, the horizontal guard rail, and the verticals of trees that frame a receding set of horizontals going back toward the mountain. I didn't intend any of this as I was painting: I was simply looking. But I find that there is an inherent compositional sense at work from my training, from my looking at other paintings and at different landscapes—that sense asserts itself even when I'm working very intuitively and very quickly. I think it's necessary to trust that intuition.

LEWIS MOUNTAIN
FROM THE NORTHWEST
1977, oil on canvas
16" x 18" (40.6 x 45.7 cm)

This painting deals a bit more with diagonals than the others do. It has some of the horizontality most landscapes do, but here I was picking up on the steepness of the hill, and trying to find echoes of that slanting in other parts of the landscape. A lot of my paintings are built on a system where one form echoes another form: the shape of the road in the foreground will parallel the shape of the hill in the background; a tree's vertical will echo the edge of the canvas; or a bush will refer to the shape of a hill.

GEOMETRIC STRUCTURES
IN THE LANDSCAPE

HOW A PAINTING HAPPENS

For my smaller works, I buy museum-quality watercolor rag board by the sheet, and cut it to size with a saw, producing a rough edge that resembles a deckle. When I want a clean edge, I score the rag board with a mat knife guided by a metal ruler (never use a wood or plastic ruler to guide your blade, since a razor edge can cut into these materials). Then I gesso the painting surface, and after the gesso is dry, I cover it with a light wash in a medium value of some earth tone. Toning the surface is useful for almost any kind of painting, because it allows you to work both dark-into-light and light-into-dark. With both methods at your disposal, you should be able to work up an image quickly, which is a real asset when you're painting out in the field.

I use a variety of surfaces: usually canvas or linen, watercolor board for the smaller paintings, and from time to time Masonite and plywood. Plywood is a good support for painting. As far as I know, the higher grades are quite permanent and stable, and the smaller sizes are not liable to warp. Masonite has a slick, fast surface that will give you a thin, brushy painting that can be reworked later. I use untempered Masonite; it's a little bit slicker than what I usually like, but that can be controlled by the way the gesso is applied and the number of coats. For a small, quick painting it can be quite handsome. Masonite has a very nice tone to it, and if the surface is sized with rabbit skin glue and not gessoed, you can use the tone of the board in much the same way old masters used their sized mahogany panels. With Masonite, you are always very aware of the slickness and thinness of the paint. There is less opacity because the surface doesn't have the tooth that canvas does. I think surface and texture become less important in my paintings on Masonite; although, the way I let the Masonite show through becomes a very subtle texture in itself.

The convenience of oil on paper is wonderful, and its use is widespread, but be careful to seal the paper surface with gesso. Even with gesso and the use of acid-free paper or rag board, the permanence of this kind of oil painting is in question. It's always possible for an expert conservator to mount such paintings on canvas if necessary, but this is an expensive operation.

To define texture in my smaller paintings, I use sable brushes, usually flats, which let me paint wet-into-wet with less chance of muddying the painting. The flats also give me the control that I need. The surface of my paintings on canvas is interesting to me in itself, and it usually varies a lot within a given painting, depending on the action of the brush and the textures I'm involved in representing. In different areas of the same painting, I might use a palette knife or a thin wash.

Over the years I've developed a palette that I find particularly suited to landscape painting. The idea is to bracket the spectra, so you have a good range of each important color, and whatever you need to mix the extraordinary colors. I don't use black; I like to mix my own blacks, since I find ordinary black pigments dull out other colors. My standard palette is as follows:

titanium white
Naples yellow
yellow ochre
cadmium yellow light
cadmium yellow deep
cadmium orange
cadmium red light
alizarin crimson
mars red
burnt sienna
raw umber
ultramarine blue
cerulean blue
chrome green opaque

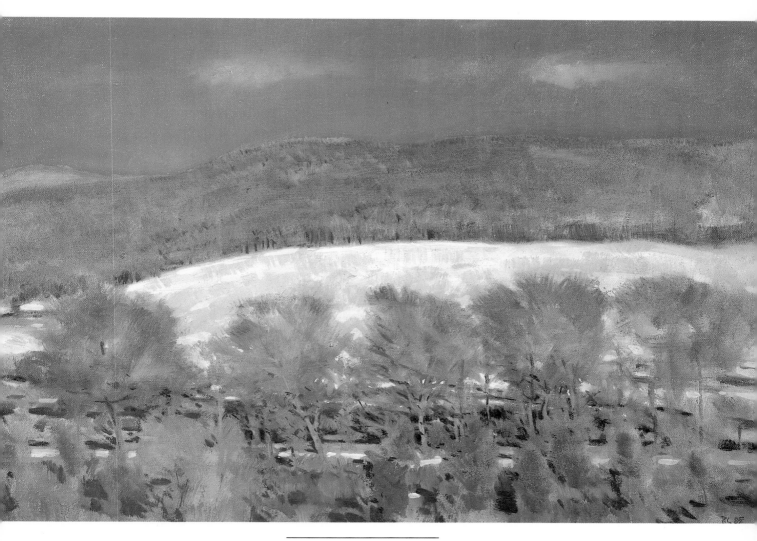

SNOW IN THE SOUTHWEST MOUNTAINS
1985, oil on canvas
12" x 18" (30.5 x 45.7 cm)

This was begun as a plein air painting, but I abandoned it unfinished, as sometimes happens—I think it may have begun to rain or something when I was out painting it. I picked it up again some months later and finished it. This was very meticulously painted—I worked for a long time with very small brushes, trying to define all those textures. I used sable brushes to paint in the very subtle lights for grasses, and to suggest the branches of trees. There are also very strong darks, in the shadows cast behind the trees, which are very sharp and crisp. The sky, in contrast to the textured ground, is a smooth wintry gray. I like winter as a time to paint because the color is subtle, and the light is often very clear. The dryness of winter brings a starkness to the landscape that I find very interesting.

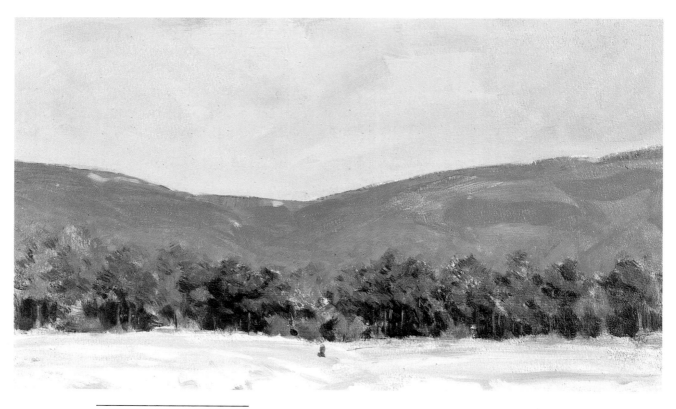

SNOW AT YANCEY MILLS
1983, oil on rag board
8″ x 14″ (20.3 x 35.6 cm)
Collection of G. Remak Ramsey

In this quickly painted piece, the simplified bands of sky, mountain, trees, and snowy foreground with a small object in the field—a blue 55-gallon drum that was out there for some reason—were what caught my attention. Much of the work in this painting was done by brushstrokes alone: the force, the touch, the direction of the brush when you are blocking in areas can suggest the contour of the shapes you see before you in the landscape. Using brushstrokes to describe contours is part of the process of simplification, an economy of means, that I find very rewarding in painting.

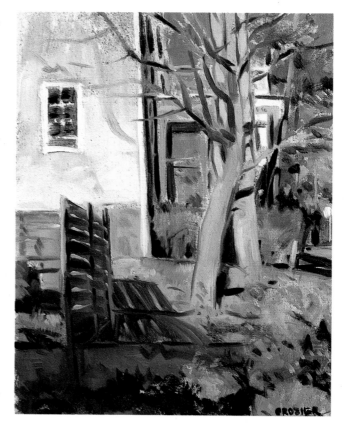

CARY'S HOUSE
1985, oil on rag board
8″ x 6″ (20.3 x 15.2 cm)
Collection of G. Remak Ramsey

I painted this little study of a backyard very quickly, in about forty-five minutes. It's very lightly, very thinly painted in some places, such as the area above the window of the house, where you're simply seeing the ground of the painting showing through. I liked the clear light and the blue sky that was coming through the trees and the screened porch. The very sharp, clear shadows seemed very exciting. Since the trees overlapping each other were about the same color, I tried to distinguish them through the placement of shadows.

COMPOSING A PLEIN AIR PAINTING
DEMONSTRATION

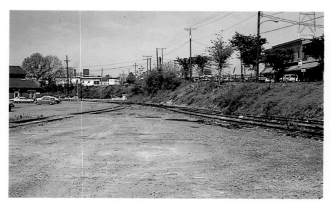

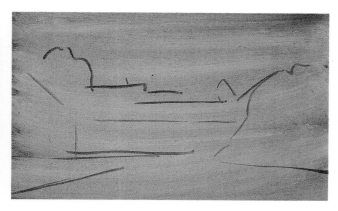

SITE OF RAILROAD LOT, CHARLOTTESVILLE. *I chose to paint this site for its structural complication: the interesting perspective of the curving rails, the greenness of the plants against the overall gray of the lot, and because it was across the street from my studio.*

FIRST STATE (SKETCH). *First, drawing in a thin wash of color with the brush, I laid down a sketchy structure. I wanted to be sure I was getting the proportions right before getting too specific about the shapes I was actually seeing. This structure sets the scale of the painting, as well as relative proportional measurements, the skeleton of the composition.*

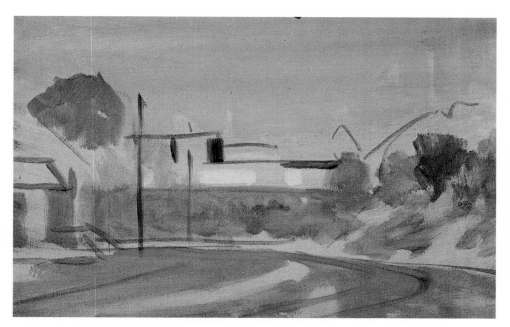

SECOND STATE. *At this point, I began to think about color and tonal relationships: notice the white of the buildings, seen against the tan wash of my painting ground. I always try to be as economical with my brushstrokes as possible incorporating as much information—whether it's texture, volume, or gesture—into each movement of the brush. As you can see, at this stage I had already begun to suggest the texture of things.*

THIRD STATE. *At this point, I began to sharpen the contrasts and add details. This is the point where a plein air painting begins to come into focus.*

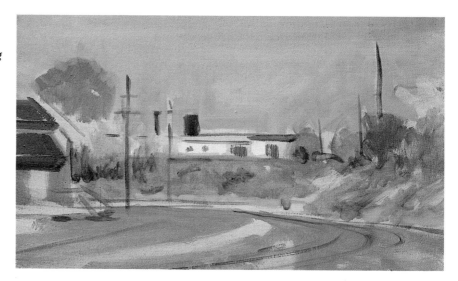

FOURTH STATE. *Focusing is a gradual process, and at this stage I was concerned primarily with defining textures and tightening contrasts. I was also being careful that there was a consistent sense of light throughout the painting.*

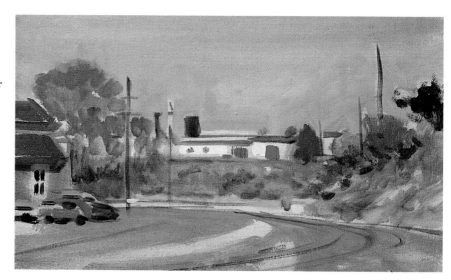

FIFTH STATE. *As I finished my on-the-spot work on this painting, I decided to overplay the contrasts a little, in order to make a stronger, more compelling image. I knew it would be easy to tone down the colors, if I needed to, in the studio. In heightening the greens in the painting, however, I marred the atmospheric perspective inherent in the tonal relationships I had set up, and destroyed the illusion of space in the painting.*

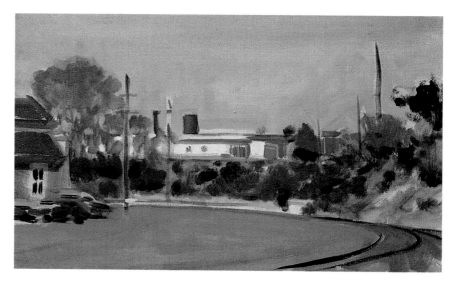

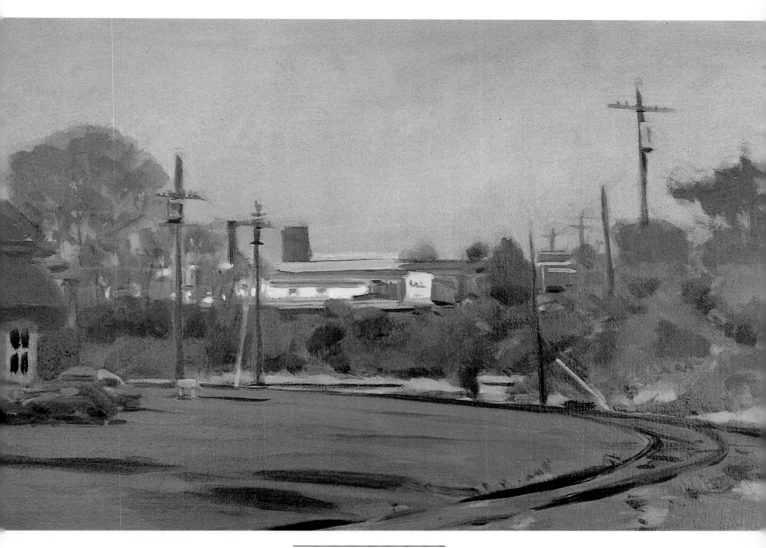

**RAILROAD LOT,
CHARLOTTESVILLE**
1988, oil on rag board
8" x 12" (20.3 x 30.5 cm)

*With some reworking in the studio, I was able to salvage the
grayness of the atmosphere and put the space I wanted back into
the finished painting. I added grays, softened colors that were
too bright, lessened some overstated contrasts, and added stray
details to complete the picture I wanted.*

II. SUBJECTS

**RIVANNA VALLEY,
LATE AUTUMN**
1980, oil on canvas
42" x 49" (106.7 x 124.5 cm)

ATMOSPHERE, LIGHT, WEATHER

Atmospheric perspective is important in many of my smaller paintings. Distance, light, and atmosphere affect texture, value, and color, so that things close to you seem sharp and crisp, and the things in a receding landscape become less and less distinct—the colors become softer.

The direction of the light in a landscape will influence the way the topographical information is picked out. The direction of the light can also be an important compositional device—giving you strong diagonals, or a visual rhythm to the way the shadows fall on the landscape.

Weather is the most important variable in the landscape. A site can change past recognition with a change of weather. The difference in light, color, and form between a dry meadow and the same field flooded after heavy rains is enormous, from the point of view of a landscape painter. Even a few degrees' difference in the angle of sunlight, or the movement of a few clouds, can change the entire mood of a site.

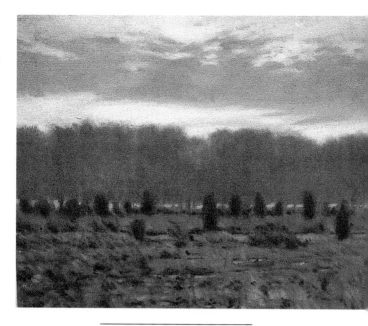

NEAR THE JAMES
1984, oil on canvas
14" x 18" (35.6 x 45.7 cm)

This is an observational painting, with some work done in the studio. The site was a low, swampy ground, with water and field reflecting the sky. There was a light sky of clouds flowing through, as though a storm had just ended. The small cedar trees articulate the ground plane nicely.

OFF 29 NORTH
1980, oil on canvas
12" x 14" (30.5 x 35.6 cm)

I was looking through a screen of pine trees at the landscape and buildings behind. Done entirely on site in the winter, this is a very moody, atmospheric painting. The simple, geometrical organization of this composition served as a model for some of my larger paintings.

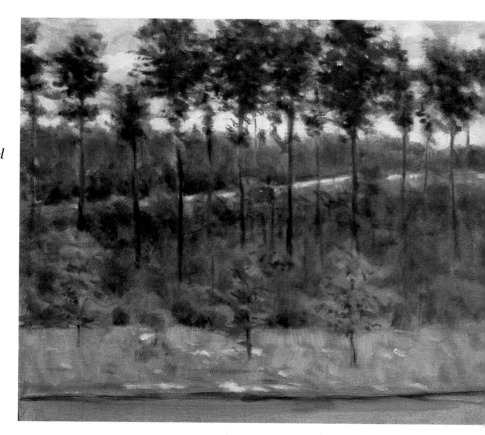

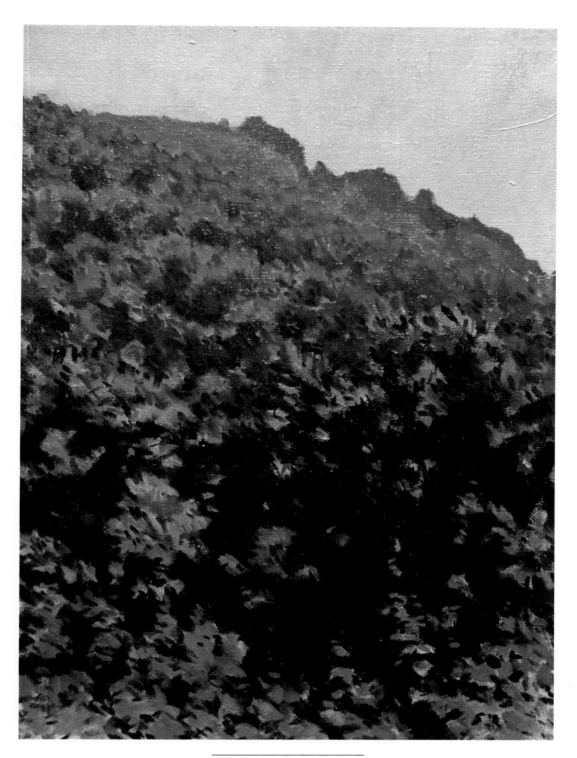

THE PINNACLES
1984, oil on canvas
20″ x 16″ (50.8 x 40.6 cm)

This is a view of the side of Old Rag Mountain beyond Madison, Virginia, on a hot summer day with a lot of haze in the air. You really feel that atmosphere intervening. I like the simple organization in this piece, which is simply about looking up a hill and trying to get some sense of scale: a big subject painted on a small canvas.

WINTER
1978, oil on canvas
14″ x 18″ (35.6 x 45.7 cm)

The way the snow showed up between the masses of trees that were disappearing into the distance, and the marks that were in the snow, interested me. It was a very enclosed space; I felt as if I was in a valley.

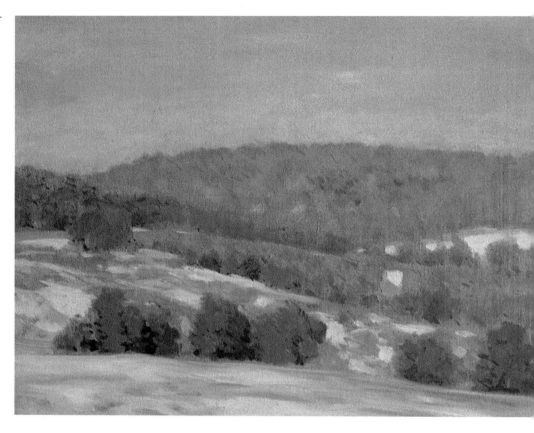

WINTER, WAYNESBORO
1981, oil on canvas
14″ x 18″ (35.6 x 45.7 cm)

In this fairly rough country, I was looking at a large exca-vated hillside with snow on it, paying close attention to the way the snow clung to the trees. I was also getting the feel of the amount of moisture in the air—the silveriness or haziness that often occurs in bright light when the weather warms up after a snowfall.

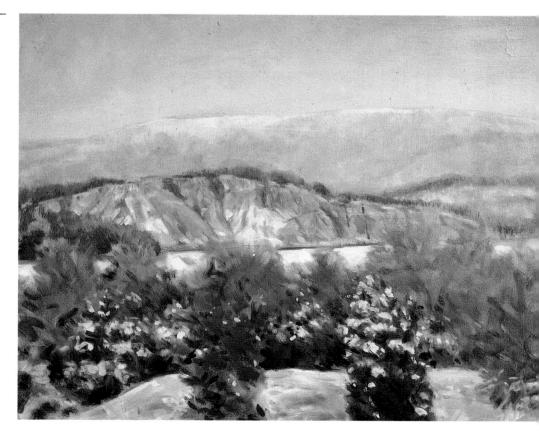

WINTER SUNSET
1977, oil on canvas
14" x 18" (35.6 x 45.7 cm)

This is a very dark painting: in fact, all of the colors have gone down to one value, except the streaked salmon color in the sky. I painted this on my way home after teaching in the late afternoon in winter. Just looking out at that gray, horribly depressing scene, I picked up that beautiful salmon color in the sky.

SUNSET, FRYE SPRINGS
1977, oil on canvas
12" x 18" (30.5 x 45.7 cm)

In this atmospheric sky study, I was looking at the difference between the light in the sky and the areas of foliage on the ground plane, darkening as the sun went down. I was mostly interested in color, and I was trying to be very specific about the colors I saw.

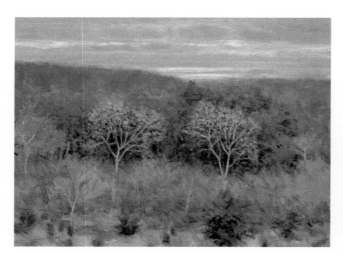

SYCAMORES, WINTER
1976, oil on canvas
14" x 18" (35.6 x 45.7 cm)

The way sycamores—with their dead-white branches—often retain their leaves for a long time, makes them look very strange, like photographic negatives of trees. I was trying to deal with the fuzzy haze that the limbs of bare trees make against the streaky autumn clouds high in the atmosphere.

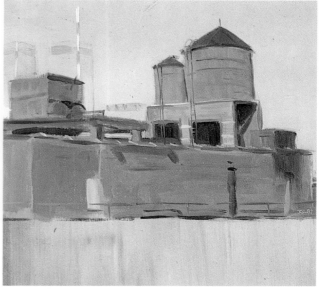

WORLD TRADE CENTER
FROM TOM BOLT'S ROOF
1986, oil on rag board
10" x 10" (25.4 x 25.4 cm)

This is a quick study of an urban landscape, with the World Trade Center towers seen in the distance. There's a lot of modulation of color in the atmosphere over a large area in a polluted, industrial city like New York, which involves an entirely different set of colors than the palette I use for rural areas. I'm always willing to try a new landscape. Here, I was trying to get a sense of the rhythm that comes from the geometry of city rooftops.

WINTER NEAR VERONA
1987, oil on canvas
18″ x 24″ (45.7 x 61.0 cm)

This painting was done from repeated observation and memory. What I was interested in is that phenomenon where the hills in the background are almost the same value as the atmosphere. Another interesting thing is how the trees are picked out by the sunlight on them; as they emerge from the very cool blue shadows, they become warm on top.

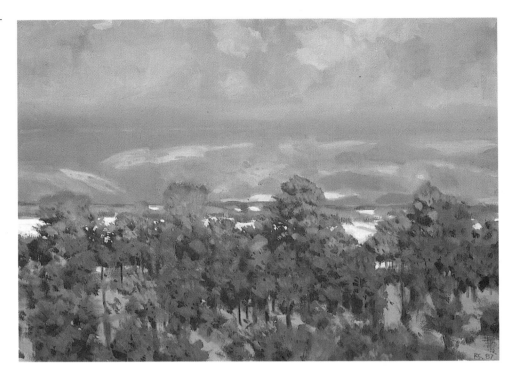

SILVERY LIGHT
1981, oil on canvas
16″ x 18″ (40.6 x 45.7 cm)

Backlighting, the glare off the leaves, and the light coming down sharply onto the dry grass are all important subjects in this painting. I needed to change my palette in order to obtain these very different colors, which can sometimes be a liberating experience for a painter.

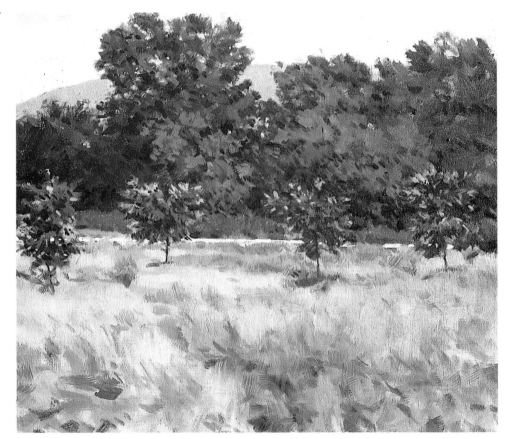

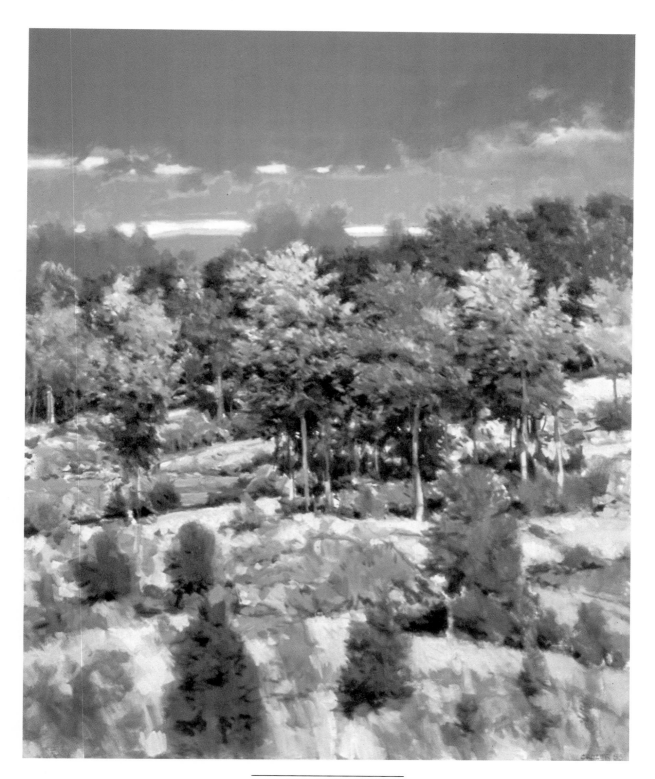

SWIFT RUN GAP
1983, oil on canvas
60" x 48" (152.4 x 121.9 cm)

This is a section of landscape I saw looking up the side of a hill.
The bright vibrant colors of the Virginia fall against a dark,
ominous sky had all the density and pressure of a fall day. I was
trying to get the feeling of space receding away from the viewer
and up the side of a hill.

GRAY AND WINDY
1976, oil on canvas
16" x 18" (40.6 x 45.7 cm)
Collection of Kapka-Ashlock

This is an early spring painting. The atmosphere was very moist that day, with clouds blowing across the sky, the bare tree was almost invisible against the dense background. The shadows it cast gave me a better understanding of that tree. It also served as a ready-made marker for scale in the center of the painting.

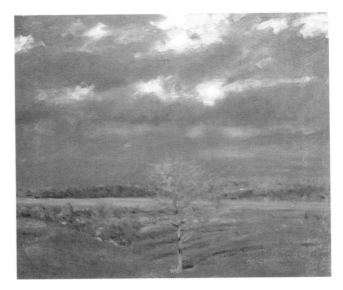

NEAR WINCHESTER
1983, oil on rag board
10" x 15" (25.4 x 38.1 cm)

In this study of clouds and the low landscape you see below the horizon line, I was looking out over very flat country, with mountains barely visible in the distance. Most of the emphasis was given to the shapes the clouds made, and the atmospheric modulation of color from the bright blue overhead to a very pale color, almost a gray, at the horizon.

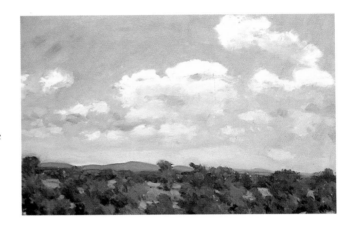

CLOUDS TO THE NORTH
1977, oil on canvas
12" x 16" (30.5 x 40.6 cm)

Although this is a motif I painted many times, it still interests me: the way clouds and trees define space, and the echoes between the shapes in the clouds and in the trees. This is a very small, quick, and intimate painting.

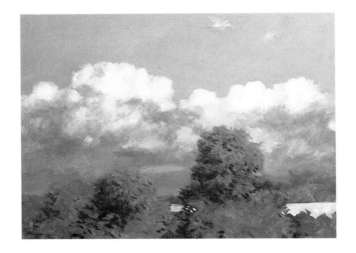

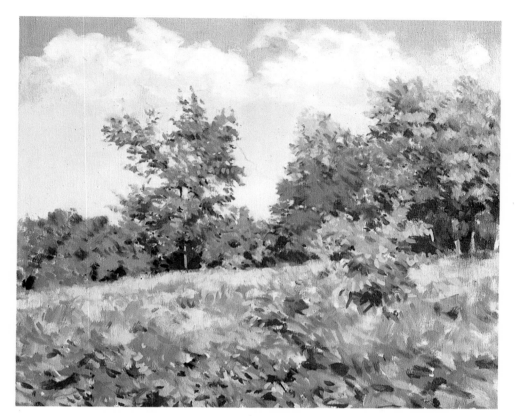

BREEZY
1982, oil on canvas
16" x 18" (40.6 x 45.7 cm)

This was painted on a clear, sunny day with lots of color. I was looking closely at the sumac and the deciduous trees changing color. I wanted to get the feeling of the cleanness of the atmosphere, and just the delight of a clear fall day.

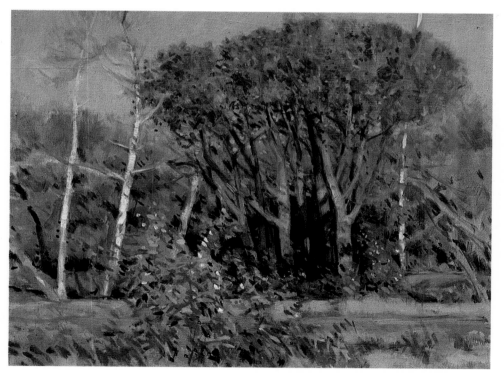

STAND OF TREES, EARLY SPRING
1982, oil on canvas
14" x 18" (35.6 x 45.7 cm)

I'm always drawn to the odd colors and configurations of the landscape in transitional periods between seasons. It's a time when you see a range of colors from the reds of budding trees to the yellow-green of maturing leaves, along with many other unusual colors. I always look for oddities in the landscape—an unusually-shaped stand of trees, or a strange juxtaposition of forms or colors.

RED BUDS
1982, oil on canvas
14″ x 18″ (35.6 x 45.7 cm)

This was another early spring painting. I was looking at that odd spring moisture in the atmosphere, and the way the trees that were just budding out seemed to color the air.

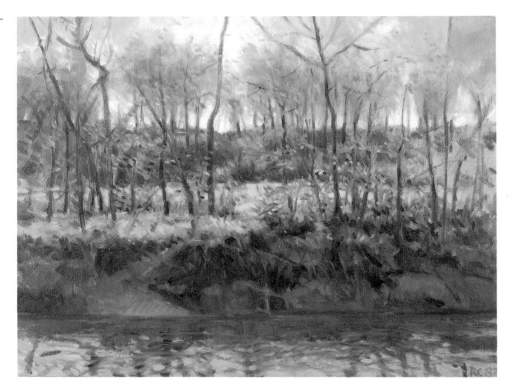

SNOWFALL
1981, oil on canvas
14″ x 18″ (35.6 x 45.7 cm)

I did this painting from my memory of looking up a hill while it was snowing, and watching the hill disappear into the atmosphere because of the snowy thickness of the air. This is very much a painting about trying to capture the atmosphere.

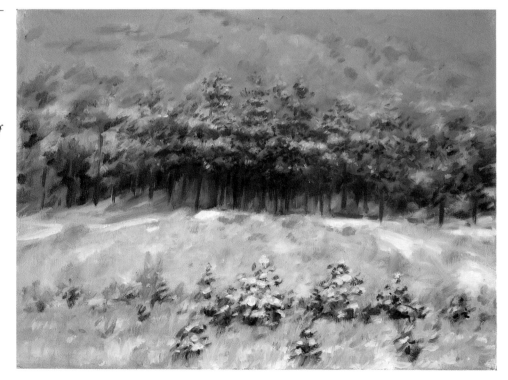

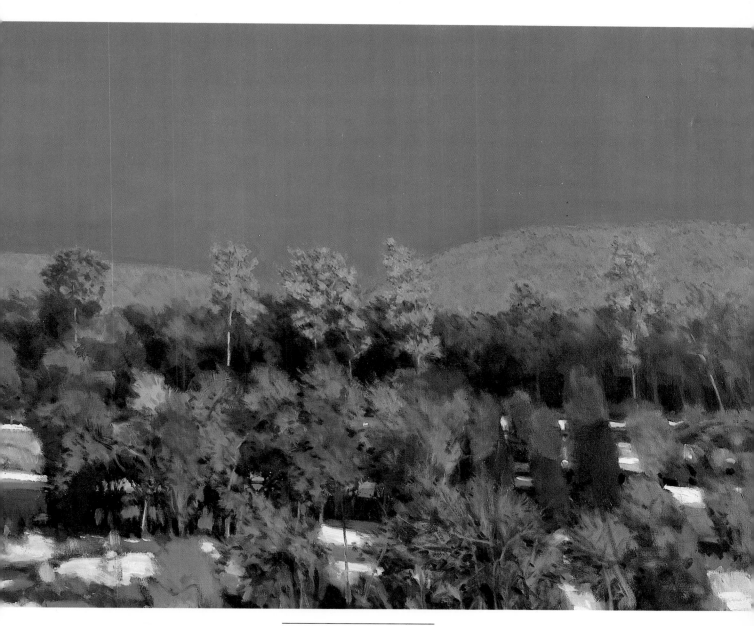

IN SHENANDOAH
1982, oil on canvas
36" x 48" (91.4 x 121.9 cm)

I particularly like this painting, which was invented in the studio. It deals with very strong contrasts, the kind you often get with snow and bright sun: dark sky and sunlight on the hills. This kind of land is not virgin wilderness by any means. It has been cultivated, left fallow for some time, and a second growth is appearing—land temporarily abandoned.

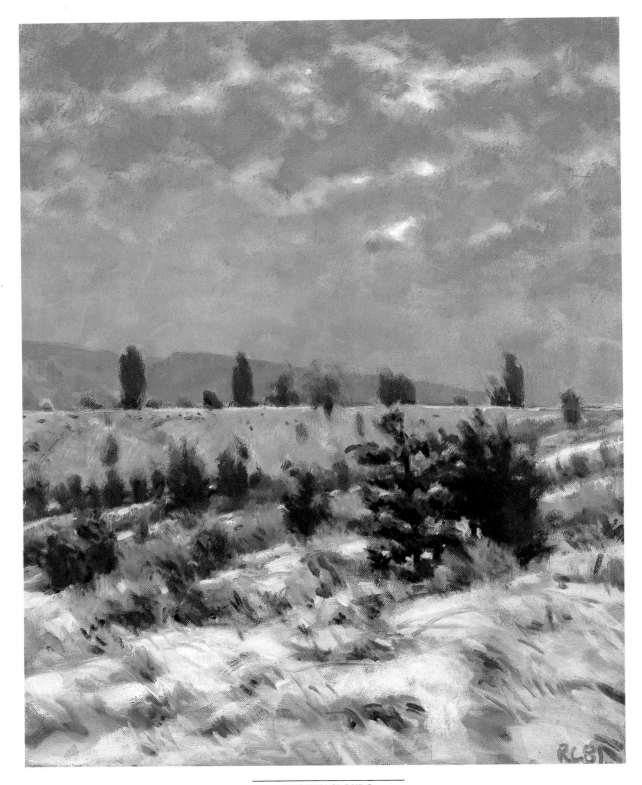

BROKEN CLOUDS
1981, oil on canvas
18" x 14" (45.7 x 35.6 cm)

*I was quite happy with this painting because I thought I was
able to capture a convincing sense of atmosphere. The colors
and values seemed to be about right. I liked the way the broken
sky allowed just a little light onto the landscape.*

CLOUD STUDIES

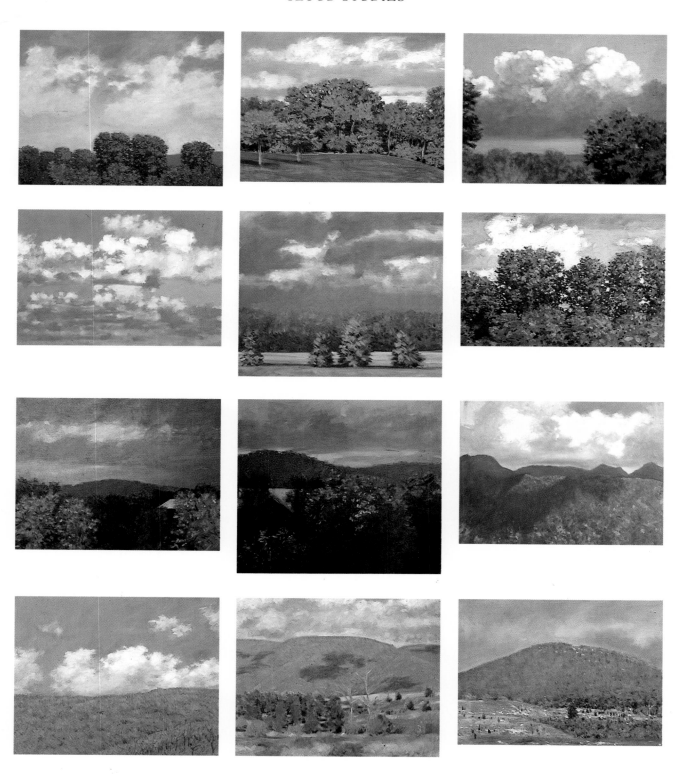

HUMAN INHABITATION OF THE LANDSCAPE

When you see land that has been mowed or manicured, land where plants have been controlled and cultivated, or land where buildings are being constructed, you're seeing a balance between human will and a certain natural anarchy. This is a subject that interests me. One of the things that excites me about landscape painting is trying to find that compromise: the balance between the human imposition of order on a landscape, and that landscape trying to find its own order.

I'm always curious to see what developers put in the areas that they clear off. For instance, the small trees planted in parks or parking lots that are meant to give a little shade and definition to broad, and sometimes, unattractive open spaces will sometimes add an unintentionally surreal touch to a landscape. For a painter trying to establish a convincing space, such trees are useful because they can also help give scale to the painting.

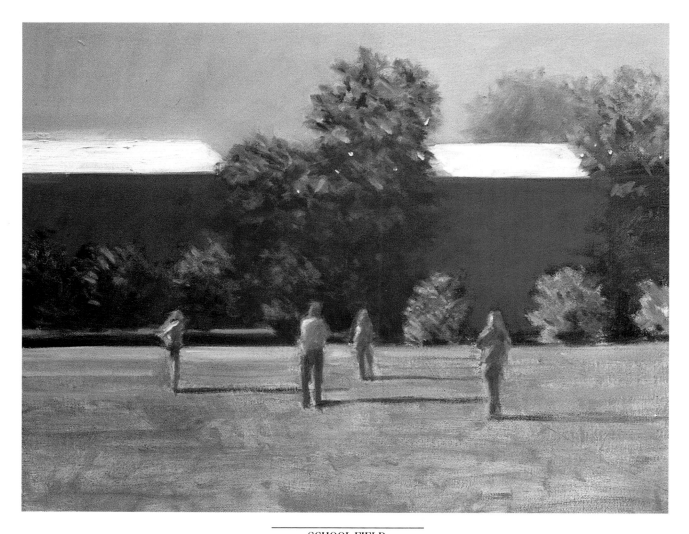

SCHOOL FIELD
1976, oil on canvas
14" x 18" (35.6 x 45.7 cm)

I had done a number of paintings with figures in them in graduate school, and this was a look back to that earlier interest. In this painting I was thinking about people out in a field playing some game; it could be tossing a Frisbee around or playing baseball. The building just became anonymous, not a real structure but an arbitrary feature imposed upon the landscape.

SAND TRAP
1986, oil on canvas
14″ x 16″ (35.6 x 40.6 cm)

This golf course is at Pen Park, in Charlottesville. I had wandered around all day looking for something to paint, and hadn't found a thing; it was late in the afternoon, I was really depressed and thought I had wasted the whole day. Then I happened to see the sand trap, and I thought, look at that crazy, surreal thing. *It was like seeing a big footprint on the landscape. I'm interested in the funny events that seem to happen in the landscape. That sand trap was a strange, man-made event that didn't really seem to belong in the landscape—just an odd thing imposed upon the site.*

**WINTER,
JEFFERSON PARK**
1977, oil on canvas
14″ x 18″ (35.6 x 45.7 cm)

I painted those little dogwoods planted in the center of the median many, many times in different weather, different light, and at different times of the year. In this instance, I got caught up in the structure suggested by the shadows that fell across the street. There are interesting oppositions at work when architecture forces structure upon a site like this; you have the hard edges and surfaces of the roads, the bank, and the driveway, but you also have nature struggling against them and trying to soften their geometry.

**PINEY MEADOW,
CHRIS GREENE LAKE**
1976, oil on canvas
12″ x 18″ (30.5 x 45.7 cm)

This is a very ordered land, a large-scale area that has been worked over by a park service or landscape architect. Trees are lined up, and there's been a shaping to the ground. What attracted me to this site was the sequential placement of the landscape elements. I used a body of water to set the landscape out at arm's length: it's painted from one point of land looking out, which keeps the landscape at a distance. Since you're not in the landscape, it becomes something quite different.

YOUNG MAPLE
1978, oil on Masonite
10″ x 14″ (25.4 x 35.6 cm)

There is a strong sense here of the man-made geometry imposed upon the landscape. This is unquestionably the ordered landscape, ground that has been cleared and civilized for human enjoyment. Many of the trees were planted, others removed, and the landscape had been sculpted.

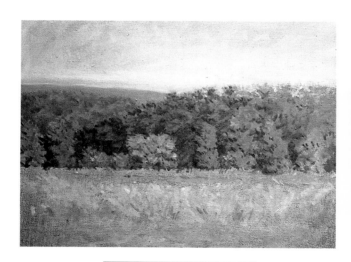

HIGH FIELD
1976, oil on canvas
14″ x 18″ (35.6 x 45.7 cm)

These trees were lined up almost like jars in a Morandi painting, all in a row, with a broad, flat foreground and a forested background. This was a motif that I worked on a lot.

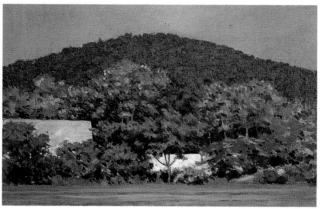

LANNIGAN FIELD
1978, oil on canvas
12″ x 18″ (30.5 x 45.7 cm)

In this suburban landscape, I was looking across a running track and parking lot at the backs of buildings that were partially obscured by trees. My interest here was simply in variations of texture and space.

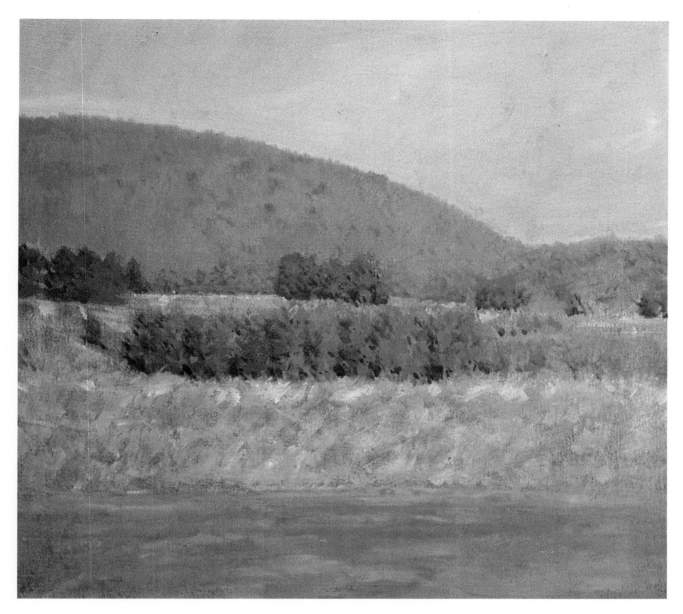

ROW OF CEDARS
1976, oil on canvas
16" x 18" (40.6 x 45.7 cm)

Piney Mountain is a very manipulated landscape, with a balance between the man-made and the natural. A lot of the plant life had been shaved off, allowed to grow back up, and shaved off again; you can feel that flux in the landscape.

AFTON MOUNTAIN
1976, oil on canvas
16″ x 18″ (40.6 x 45.7 cm)

Looking up toward the Blue Ridge Mountains, I was trying to get down the color of the mountain. I also wanted to play its textures against the textures of the little pine trees next to the parking lot. It seemed to me that to capture the sense of atmosphere was a perfectly good reason to make a painting like this. It's a very simple painting—really just a few trees seen against a background, noting the change in focus from near to far. I was trying to get a convincing sense of space and trying to feel out what some of those very difficult and ambiguous colors were in the background. Getting the colors right was probably my greatest challenge in these types of paintings, something that I have struggled with and will continue to struggle with for a long time.

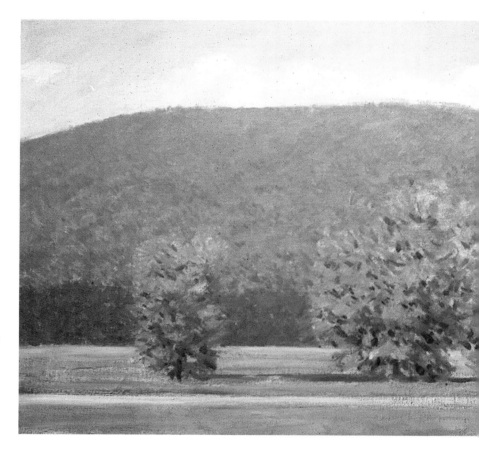

EMBANKMENT PINES
1975, oil on canvas
14″ x 18″ (35.6 x 45.7 cm)

The big open area in this painting was close to where I lived at the time. One thing I like about this painting is the way it confronts you with a single tree that almost seems stuck against the embankment. The tree stands out because there's a very strong change in texture from the fairly smooth bank, with its mowed grass, to the rough pine foliage.

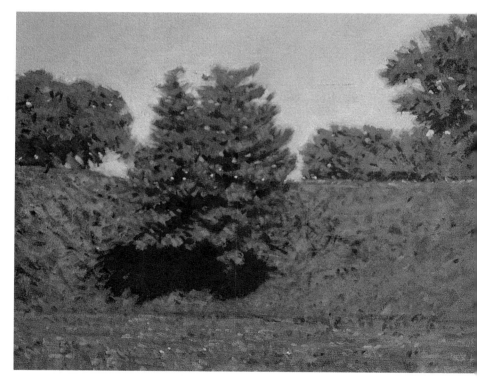

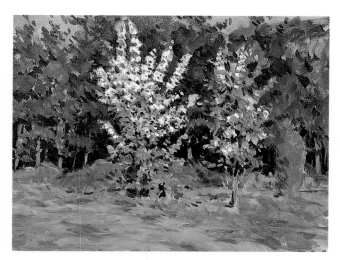

FRUIT TREES
ON RIO ROAD
1982, oil on canvas
14" x 18" (35.6 x 45.7 cm)

I found the stark white of flowering trees against the dark, dense pines and the deciduous trees behind them the most compelling feature of this site. The presence of fruit trees was a kind of accident in the landscape—trees that had been planted and cared for were now abandoned and forgotten, perhaps when a farm or a house disappeared.

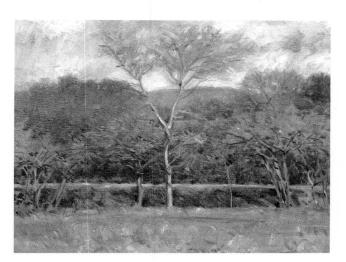

EARLY SPRING
NEAR RIVANNA
1975, oil on canvas
14" x 18" (35.6 x 45.7 cm)

I liked this painting quite a bit, because it seems to say a lot to me about spaces that were once cultivated and allowed through neglect to lapse back to nature. There's something very cyclical in the way land is used, allowed to lie fallow, and then used again. There's always a trace of people having been there. This was painted outside, judged a failure, brought back into the studio, and reworked pretty heavily—changed almost completely from its original version. There's almost a Civil War quality to it, similar to the atmosphere you see in some of those old photographs.

ALBEMARLE SQUARE
1978, oil on canvas
12" x 18" (30.5 x 45.7 cm)

As a landscape painter, I see a lot of land being developed around the country. On the one hand I sort of hate to see it happen, but on the other hand there's something that fascinates me about the process of construction. On this site there were big pallets of brick that caught the light in an unusual way and turned them into unexpectedly beautiful structures. This painting is important to me, because it's a kind of document: a record of something that I caught in the act of disappearing.

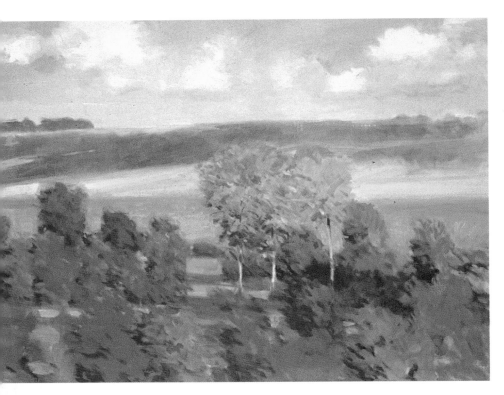

PLOWED FIELDS
1977, oil on canvas
14" x 18" (35.6 x 45.7 cm)

This was painted looking out over a very long distance at broad fields. The closest field was plowed, so red dirt was exposed; this made a sharp contrast with the foreground of uncultivated hillside.

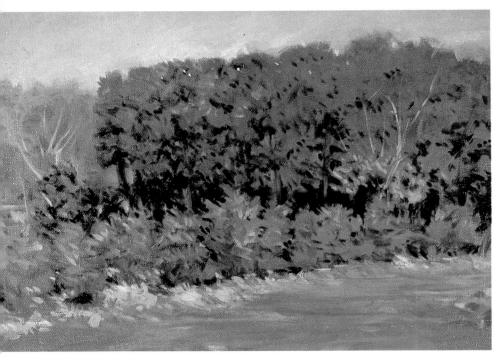

DIRT ROAD
1975, oil on canvas
14" x 18" (35.6 x 45.7 cm)

This landscape shows the different marks that people made on it: a dirt road cut into the earth; trees arranged by the way that people have cleared land; and an older forest which, for one reason or another, had not been cut, with new growth coming up in front of it. I never quite understand the process of clearing land—why people leave the things they do, and why they take the things they do. I'm always encouraged to see a second growth come up; it always comes back thicker and stronger after it's been shaved off. It is often quite interesting in terms of color: new bright greens seen in contrast with the remains of the old forest—the stumps and abandoned logs.

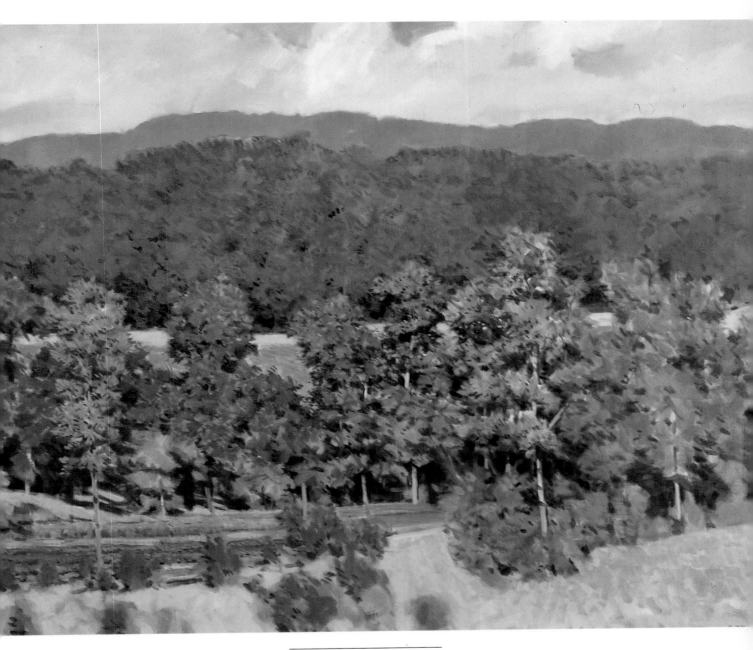

GARDENS
1981, oil on canvas
48″ x 60″ (121.9 x 152.4 cm)

*In this painting my subject was the man-made structure in the
landscape, the manipulated areas of the landscape as seen
against areas left untouched. I often look for that juxtaposition.
Here, the fields are separated by uncultivated strips. The
cleared ground leads you into the picture, disappears into the
trees, and reappears on the other side of them, making for some
interesting contrasts.*

SEASONAL MOVEMENT

The most widespread change in any landscape is, of course, the seasonal change. I find the oddness of color during the transitional periods *between* seasons to be the most interesting and challenging thing to paint. There are always surprises during those periods, and things you wouldn't expect to see, such as the color of greens at the moment when they begin changing gradually to reds in very early autumn, or, later in the fall, when those red-greens change to grays.

In Virginia, as in much of the world, spring is the most violent season, arriving very quickly over a period of a few days. The trees you are used to seeing as gray can abruptly become a very improbable, almost plastic shade of green. Just before that leafing out, there's a time when buds fill the treetops with what can appear from a distance as a kind of atmospheric haze. Even the more stable middle spring promotes a riot of small, changing shapes in blossoming trees.

Snow can change a familiar stretch of landscape overnight from intricate complexities of vegetation to smoothed, sculptural contours. Snow also creates a very bright reflective light, with cool blue shadows. In painting the landscape, the best way to deal with these things is to look at them objectively, and to try to get down your sense of what really is there.

RED BANK
1981, oil on canvas
16" x 18" (40.6 x 45.7 cm)

Here, it was the colors changing in the foliage—a whole spectrum from green up through yellows and reds— that made me want to paint these young maples. Their color is seen against a field, full of small pines and dry grass, and an eroded embankment.

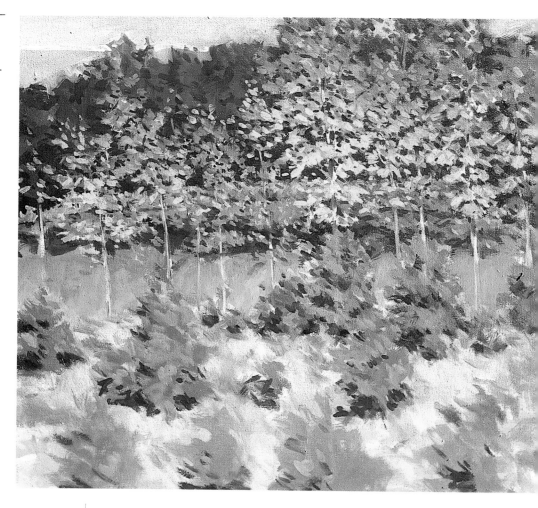

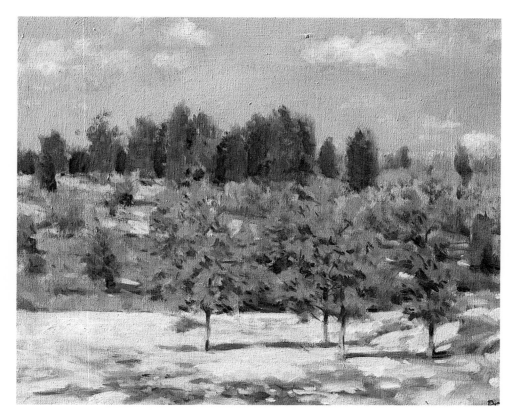

SNOW, BEAVER DAM LAKE
1982, oil on canvas
14" x 18" (35.6 x 45.7 cm)

I was looking at how snow changes the landscape: divides it, dramatizes value, and emphasizes aspects that wouldn't be apparent otherwise. In this painting the snow makes a strong contrast; it also picks up shadows strongly in bright light and emphasizes contours—notice the way the land flows beneath the trees.

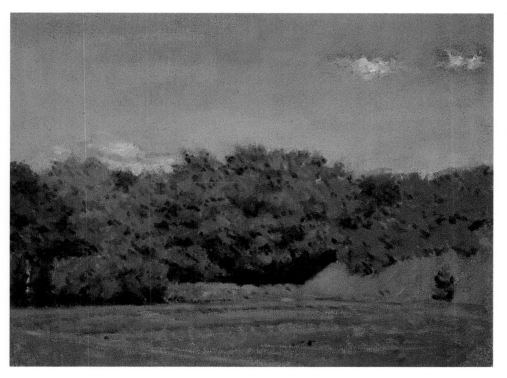

SUNNY DAY,
THE GARDENS
1978, oil on canvas
12" x 16" (30.5 x 40.6 cm)

There was a clear, clean, early summer light, and I wanted to paint the plants that were starting to grow in the garden plots.

EARLY SPRING,
PINEY MOUNTAIN
1976, oil on canvas
16" x 18" (40.6 x 45.7 cm)

Here, I was watching the colors slowly start to change in the early spring warming. This was a consciously spare composition: a domelike mountain with clear spatial gradations from the foreground. The colors are close in value, so the whole scheme is kept to a limited range of values.

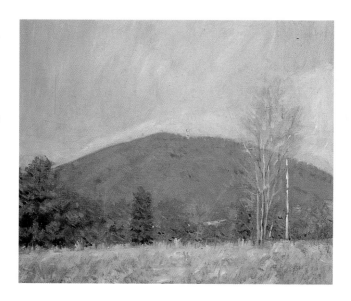

CITY GARDENS,
EARLY SPRING
1976, oil on canvas
16" x 18" (40.6 x 45.7 cm)

This land had been plowed up before the winter. When I painted this, there was a feeling of dustiness and dryness—the land was ready to be worked.

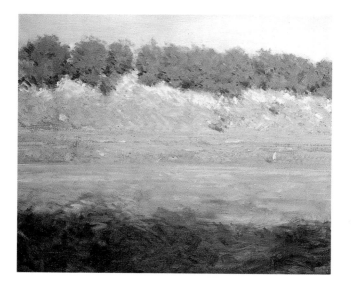

DRY FIELD
1977, oil on canvas
14" x 18" (35.6 x 45.7 cm)

I was looking up a hillside covered with tawny, shaggy grass toward a single shrub. The light and colors attracted me: red, warm tones, and the ambiguous kinds of grays that you see in bare trees. The bush itself was one of those colors that's difficult to describe—a contradiction, almost—the green overlayed with red made it an olive color. It was early spring, and the bush was beginning to pick up some green that could be seen against the brown of the background plants.

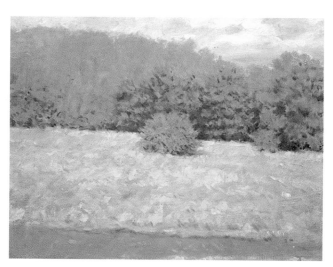

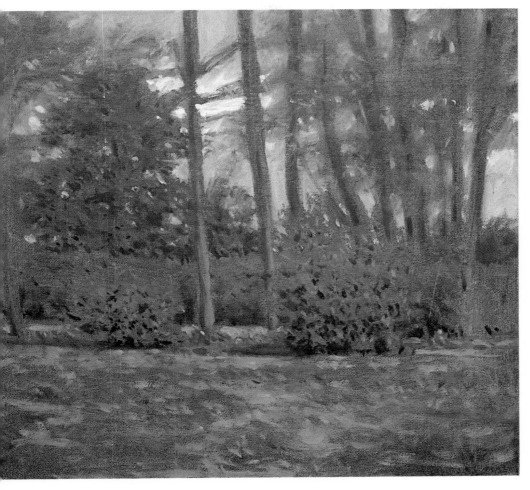

FLOWERING QUINCE
1977, oil on canvas
16" x 18" (40.6 x 45.7 cm)

I did this painting on the University of Virginia grounds. Flowering quince is one of the first flowers to bloom in the spring, and it has a very interesting color. The red flowers seen against green leaves that were just starting to bud created a complex color structure. The blooms were seen against a background of trees that hadn't leafed out yet, and the grass was still very dry and brown; it was the earliest part of spring.

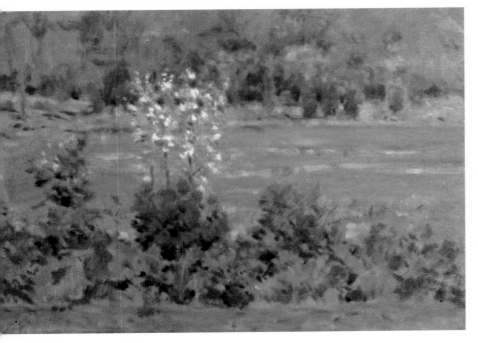

SPRING, PEN PARK
1979, oil on canvas
12" x 18" (30.5 x 45.7 cm)

This was painted at the edge of a field that had been plowed. There was water standing in the field, and dogwoods were blooming. The red dirt, which was something I found very striking when I first arrived in Charlottesville, seemed electric against the green of the grass. It took me a few years to learn how to paint that red dirt: you have to paint it much pinker and much lighter than it really appears, in order to make it sit on the canvas. This painting was about the euphoric feeling you get in the spring when things are starting to bud out—everything just seems to come alive again—the landscape is moist, and you can smell growth in the air.

RED-TWIGGED DOGWOOD
1982, oil on canvas
14" x 18" (35.6 x 45.7 cm)

There's a stand of red-twigged dogwood along a swampy area near Charlottesville. What I liked about painting the dogwood was the way the red in its branches, seen at a distance, made a kind of atmospheric haze. This is an early spring painting that is very much about a particular time and place.

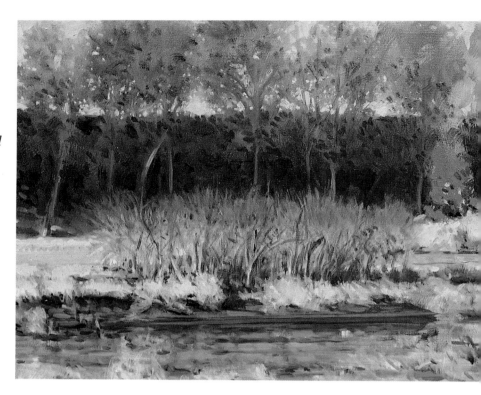

SPRING NEAR KESWICK
1982, oil on canvas
18" x 14" (45.7 x 35.6 cm)

This is an early spring painting; the weather was cold. I wanted to paint the transparency of the trees: the red buds seen against the solidity of the cedar tree. I was also trying to get down the russet, tawny brown colors of the brambles and the low, shrubby plants coming up through the dry grass, just before they begin to green out.

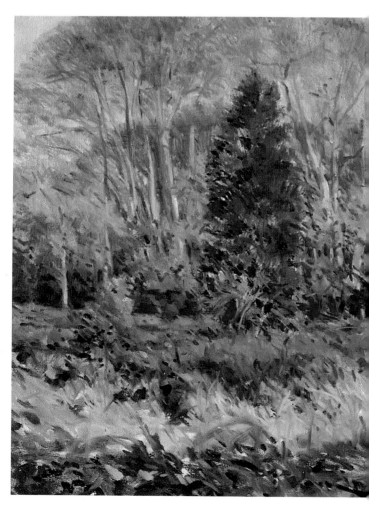

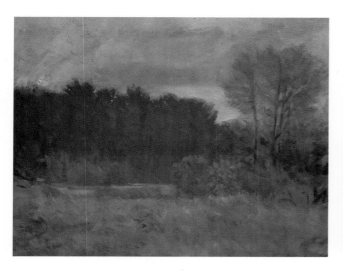

GRAY DAY
NEAR THE RIVANNA
1977, oil on canvas
14" x 18" (35.6 x 45.7 cm)

This is a very gray painting; it has a lot of the subtle colors you would see against a gray sky. I think colors read more truly when they are seen against a gray sky, rather than against a bright blue sky in direct sunlight. The palette here is a simple one: lots of ochres and earth reds, keeping quite a bit of white in the lighter colors, so that the color doesn't become too intense. I like painting in the winter because the landscape really opens up. Many winter colors are subtle; the greens are dark and earthy.

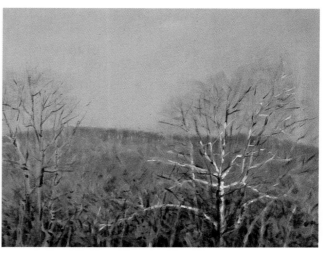

SYCAMORE AT
MINT SPRINGS
1977, oil on canvas
14" x 18" (35.6 x 45.7 cm)

Dramatic white trees seen against bare hillsides are a favorite motif with me—sycamores are very dramatic, sculptural, and gestural trees. They are, for me, an important feature of the winter landscape in Charlottesville.

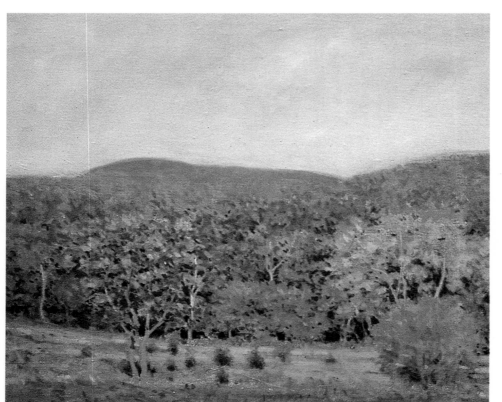

LAW MEADOW
1976, oil on canvas
16" x 18" (40.6 x 45.7 cm)

One of the things that attracted me to this site was the white sycamore trunks seen in the midst of a textured middle ground. This painting is about different kinds of texture, trying to differentiate things between the middle ground and the foreground, and how the atmosphere interferes with texture at greater distances. I liked the sense of space receding back toward mountains.

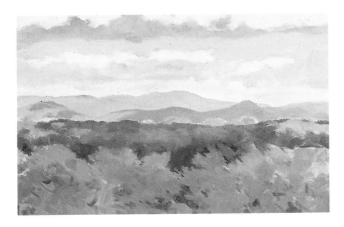

**FALL, BLUE RIDGE
WITH CLOUD SHADOWS**
1981, oil on canvas
16" x 24" (40.6 x 61.0 cm)

I was looking through autumn foliage toward distant mountains, which were picked out by shadows the clouds above them cast. My attention was focused on the modulation of light across a broad area—something I want to return to later, and perhaps work into some of my desert paintings.

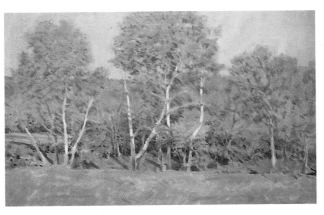

RIVANNA SYCAMORES
1977, oil on canvas
14" x 18" (35.6 x 45.7 cm)

These sycamores were a motif I had painted a number of times. This was early fall, so there's some coloring. I was looking carefully at the way the shadows of the trees defined the ground, and I was following the contours of the land in the way the shadows fell.

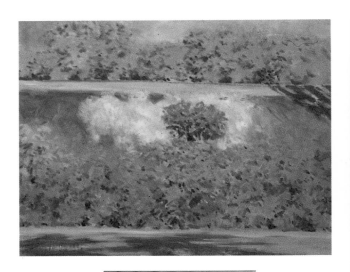

RED BUSH
1977, oil on canvas
14" x 18" (35.6 x 45.7 cm)

Pokeweed turns an interesting red color in the fall and presents an odd contrast against the other plants around it. I painted this railroad embankment many times, and was alert for anything going on there that was visually interesting. Those bushes really jumped out at me that day.

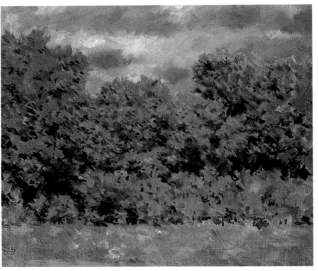

**AUTUMN,
APPROACHING STORM**
1977, oil on canvas
16" x 18" (40.6 x 45.7 cm)

I painted this at the city garden site in Charlottesville. At the time, the trees were starting to turn color, and there happened to be a heavy, dramatic sky. The massing of the trees and foliage created an organization that seemed to work for me.

AUTUMN, LAMBETH FIELD
1977, oil on canvas
14" x 18" (35.6 x 45.7 cm)

This untended yet beautiful little spot was an athletic field that was partly overgrown with different plants and textures turning color in the fall. There were also cattails, maples, and sycamores growing behind the embankment.

BEECH TREE, LATE FALL
1978, oil on canvas
12" x 18" (30.5 x 45.7 cm)

This painting has a speed about the way it was painted—about an hour. I scrubbed in the sky against the brown of the ground to suggest the broken atmospheric effect that bare trees give when seen against the sky. There is a structure here of horizontals and verticals. It was painted in very close values: squint at it and a lot of the color seems to disappear; you're left with only a spare value structure—mostly spots of dark, caught by a fairly intense, thin, and bright fall light. This painting is about the transition from one season to another, as seen in the tree from the bare branches at the top to the leaves that cling lower around the trunk. I like the way the tree starts out on top as bare limbs, and as you move down, it picks up more and more leaves until it's full at the bottom; the leaves were a coppery color against the cool grays and greens.

THE UNREMARKABLE LANDSCAPE

Around 1968, while an undergraduate in Seattle, I came to the decision that I would work with what I was familiar with, the things and places I saw around me every day. I had gotten some of these ideas from Elmer Bischoff, who'd taught at the University of Washington that summer. I had seen drawings he'd done of objects and places that were very familiar to me, and those drawings made me realize that a lot of the ordinary landscapes that I knew intimately were certainly material that could be turned into art.

I learned that there's no such thing as a place without a motif for painting: it's always there, and sometimes you have to force yourself to find it instead of having it scream out at you. The kind of painting I often like to make is not really about any particular feature of the landscape, and that really makes things perhaps all the more interesting to me, when there *isn't* a focus. When there isn't an obvious subject, you really have to *look* at everything that's there; you can't just let your subject do the work for you.

Structure, for me, is invented within the process of making the painting. I usually start without too much of an idea of what I'm going to do. There is always a sense of form at work in my paintings, but it's most often the sense of *finding* structure in a place where structure isn't obvious. I don't impose my ideas on the landscape. Instead, I try to stay receptive to the "composition" which is inherent in the site itself. My paintings

of unremarkable landscapes are also attempts at finding interest or beauty where it isn't obvious. I think that's one of the most important things that an artist can do.

It's difficult to say what draws me to a particular motif. Most often there's nothing specifically striking about a scene I'll choose to paint, no subject with a capital "S." But because of that, I have to make the painting serve my needs as an artist. I have to find that quality that will make a painting interesting, rather than having it handed to me.

I think of most of my smaller paintings as essays, in the sense that an essay is an *attempt* to do something. Someone once compared the feeling of light in my paintings to the feeling of light in the work of the abstract painter Mark Rothko. And, leaving aside the question of subject matter, I am pleased by that comparison—in their own way, these are contemplative paintings. They are also reductive paintings in a way that Rothko's are: part of the process of painting them was in trying to eliminate superfluous details, to make the feeling of the painting clearer. One of the downfalls many painters have is in trying to crowd too much detail into a painting— more than the eye sees and more than the mind remembers. The strength of Rothko's paintings is that he was able to get a tremendous resonance from simple shapes and very simple, but carefully considered, color. That's something any painter might aspire to.

**WINTER SUNLIGHT,
JEFFERSON PARK AVENUE**
1977, oil on canvas
14″ x 18″ (35.6 x 45.7 cm)

This painting has a snapshot effect that I really like. I force myself to look at an area where nothing particularly paintable is happening and thereby find a structure, interest, or motif where one might otherwise be overlooked. What I found in this case was really a kind of nonmotif— simply light and shadow.

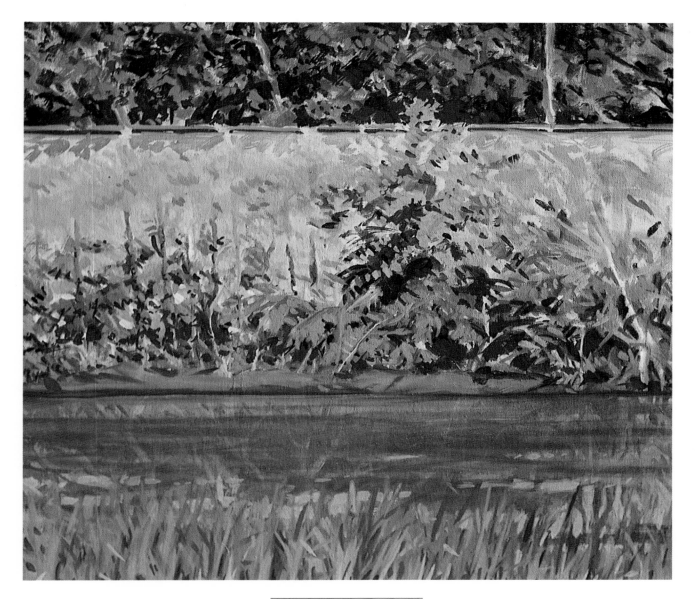

STREAM BANK
1981, oil on canvas
16″ x 18″ (40.6 x 45.7 cm)

This is a view of a stream with railroad tracks behind it. The wooded lot was at one point in danger of becoming a supermarket. Thank goodness it didn't. There isn't really a stream there, just water running in a ditch. I wanted to paint that water, the grasses coming up out of it, the bank behind it, and the way the bank and tracks divide the picture into thirds. I seem to think of landscape in layers like that. This painting has the random feeling of cropping about it that you might get from testing a camera, and not really aiming at something. This is a case of taking what was there, looking at it, and recording it without too much conscious editing. It somehow seems more real to me because of that unpremeditated quality in the process: more about our real experience of landscape.

MEADOW
1977, oil on canvas
14" x 18" (35.6 x 45.7 cm)

The trees, in early fall, were turning yellow; some small dogwoods in the foreground were a funny rust-purple color. I think it was the color scheme that attracted me: the way the sunlight came down, casting shadows and picking out details. I also like the way the textures of the grass against the textures of the shrubs and small plants were seen against the edge of a forest.

GROVE
1981, oil on canvas
14" x 18" (35.6 x 45.7 cm)

Picking a rather unremarkable bit of landscape, I was trying to get as much information as I could out of it. This was an attempt to see what was actually there.

GRAY GROUND
1977, oil on canvas
14" x 18" (35.6 x 45.7 cm)

This scrubby, uncultivated ground of gray, the color that dead, shrubby bushes turn in winter, was seen against the ochre of dried grass, red clay, and trees that were still maintaining green leaves. I was looking carefully at a slice of landscape, an undistinguished, rather anonymous slice, to see what interest it might hold, or what potential it might have.

FONTAINE AVENUE
1976, oil on canvas
12″ x 14″ (30.5 x 35.6 cm)

Here is another one of those anonymous weed lots where land had been cleared and then allowed to go back to nature for a number of years. This was painted loosely; the forms were not strongly defined. I was trying to get a sense of the atmosphere that you might see as you look back through an area of gray, bare trees, seeing the faint reds of early spring. Capturing the essence of the gray and tawny ochre grasses that have gone through winter and will soon be replaced by bright green. This was something I found difficult to paint, and I was testing myself against it.

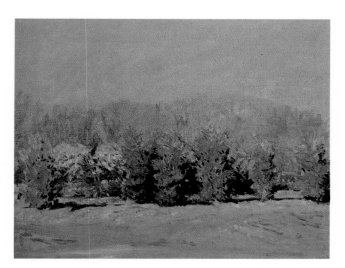

NOVEMBER DAY
OFF EMMETT STREET
1975, oil on canvas
14″ x 18″ (35.6 x 45.7 cm)

This was an abandoned area where cedars had been allowed to grow. There's a grayness to the whole palette: the brighter, more obvious colors had drained off late in the fall, and what remained were interesting, subtle transitions in color.

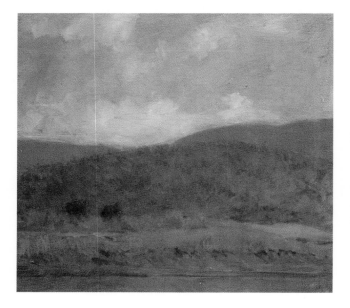

NEAR CROZET
1975, oil on canvas
16″ x 18″ (40.6 x 45.7 cm)

I painted this on a day when nothing seemed to work out—I had tried a couple of paintings earlier. The site was not much to look at: just a couple of dry hills, in the late afternoon, when things get gray. One of the things I find interesting is how important some of the small things are to this painting. The two dark trees or bushes, close together, really carry the painting because of their placement. The main emphasis in this painting is the darkness of the landscape and the lightness of the sky. It's a scene taken almost at random, and the challenge was in winnowing out what could be used to make a painting.

UPHEAVAL

The *events* in the landscape, and the ways these events can change the landscape, always interest me. So many of these events, these minor ecological catastrophes, are man-made. In painting them, my interest isn't necessarily in the critical sense that a conservationist might have—although I am very interested in conservation—but that of a detached observer, recording how the land looks when an upheaval occurs.

It's also challenging to deal with the antipicturesque landscape. By going beyond the conventional expectation of what is interesting about a landscape, a painter might hope to satisfy another, perhaps more intelligent, part of the mind. Also, the extraordinary consequences of our interactions with the landscape, whether it's an excavation for a foundation of a building, or a road being pushed through a hilly woodland area, often bring a kind of visual structure to the landscape that's entirely unexpected. A fire or a landslide can reaffirm a sense of natural order by interrupting it. Often, land is forced out of its natural order by development and then abandoned. When this happens, you can observe, over time, the slow return of a site to its natural state.

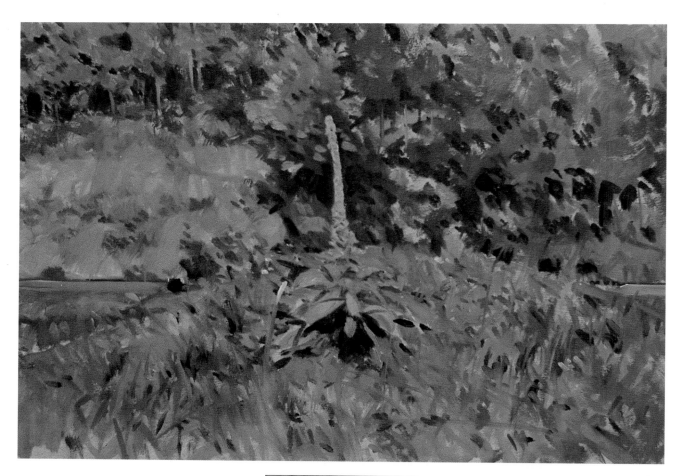

NELSON COUNTY WAYSIDE
1980, oil on rag board
11" x 16" (27.9 x 40.6 cm)

The mullein is an interesting and unlikely looking plant. Mulleins are as tall as a person—five or six feet tall—which gives them a real presence out there in the landscape. Mulleins survive all winter long as a blackened spike in the landscape. They seem to like areas where people have been, and often will grow in old abandoned sites or along roadsides. They seem to adapt to the human presence, and that appeals to me. I found this particular plant growing on a pile of gravel that was heaped up for some reason and then abandoned, grown over with plants. Interestingly enough, I passed by there this year, and there's still a mullein growing on that pile; a descendant of the one I painted, so they do persist.

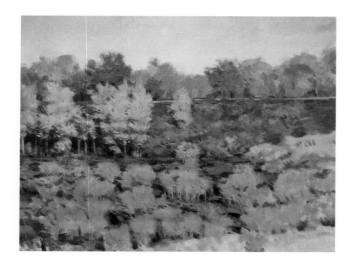

BURNED SLOPE
1987, oil on canvas
14" x 18" (35.6 x 45.7 cm)

There had been a brush fire in the area, and I was interested in the unusual, tawny brown colors that plants turn after they are burned. This was another one of those interesting events.

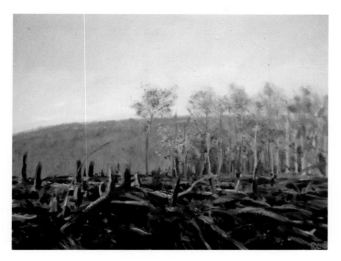

BURNED LOT
1984, oil on canvas
14" x 18" (35.6 x 45.7 cm)
Collection of Thomas Bolt

This was painted on a trip into an area that had been burned. I enjoy painting in a minor key, in somber or forbidding colors, and I was quite taken with the notion of a landscape where everything was blackened. There were some parts of the field that had been scorched but not burned in the fire, which made for a rich, unusually varied palette. This was an interesting, dramatic event. I think of something like this as a natural occurrence, just as a superhighway cut through the mountains is a natural occurrence, since we are creatures who build into and change our surroundings as ants do when they build their anthills.

HIGH WATER
1984, oil on canvas
14" x 18" (35.6 x 45.7 cm)

I liked the flat plane of puddles, which had the reflection of the sky in them, going back through the strange darkness of the trees. There were also little flecks of distant light seen between the trees. Again, there's a sense of disaster—an event, in this case a flood, that happens in a landscape.

SNOW AT CITY GARDENS
1977, oil on canvas
14″ x 18″ (35.6 x 45.7 cm)

This site was often abandoned, but because it was an area that was constantly being worked, there was always evidence of a human structure to the land and an intermittent human industry. It was, however, left alone for a good part of the year, and there was evidence of nature beginning to reassert itself in this funny, forgotten pocket of town.

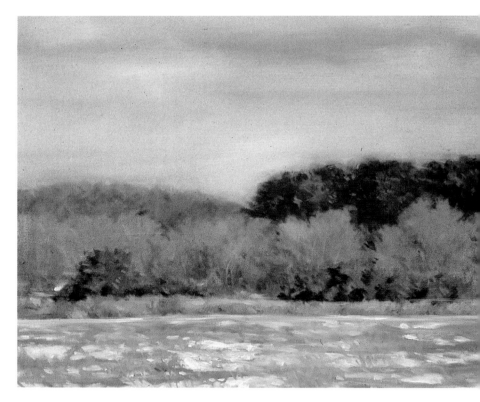

QUARRIED BANK
1977, oil on canvas
14″ x 18″ (35.6 x 45.7 cm)

At this site, the land was arranged into strata at different levels. There is a rough sort of stone in the foreground, but looking a little further back, it's more gravelly, where things are starting to grow. On top, there is scraped-off red dirt with pine trees starting to come up. There is a lot of erosion here; the land's a little too steep to hold soil. I was interested in the stripped feeling of that spot, the sense of disruption. It's as if there were a natural process laid bare in the way the land had been cut; the geological stratification has been revealed. It's not only interesting to look at, it also says something about how our human presence changes a landscape.

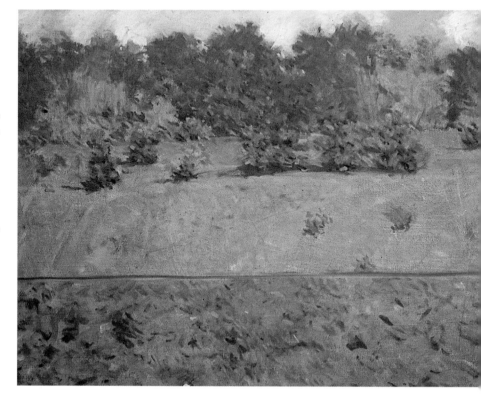

WAYNESBORO
1978, oil on canvas
14″ x 18″ (35.6 x 45.7 cm)

Waynesboro is a town between Stanton and Charlottesville, just over the mountains. The mountain was being stripped and mined for gravel, which makes the land resemble the Southwest. I was looking up back at the mountains, and the clouds boiling up above them. You can see a little bit of the cut from the strip-mining, which has gotten much bigger since the year I did this painting, and the tops of houses.

FREEWAY CUT
1976, oil on canvas
16″ x 16″ (40.6 x 40.6 cm)

I was looking at the cut that the interstate highway made coming up the mountain. It was interesting to me the way the freeway was like a big mark or scar in the landscape.

EROSION AND MEDIAN
1977, oil on canvas
14″ x 18″ (35.6 x 45.7 cm)

I really like what happens to the areas where the earth is laid bare, as in this big area that was cut away for building. You can see the marks left by the machines that did the cutting; interesting textures and colors were revealed. There's a loose kind of a structure here, made up of the flat road, the incline of the median strip, and the bushes poking up out of it. There is a lot of space just barely defined between the median and the cutaway area of the excavation.

TREES AT MINT SPRINGS
1978, oil on canvas
14″ x 18″ (35.6 x 45.7 cm)
Collection of Bennett-Shoyer

These trees were starting to be covered with kudzu vines. The vines simplified the shapes they covered, making them dense and tight, so they caught light in interesting ways. Kudzu vines tend to drape whole stands of trees and make them into very sculptural, rounded shapes.

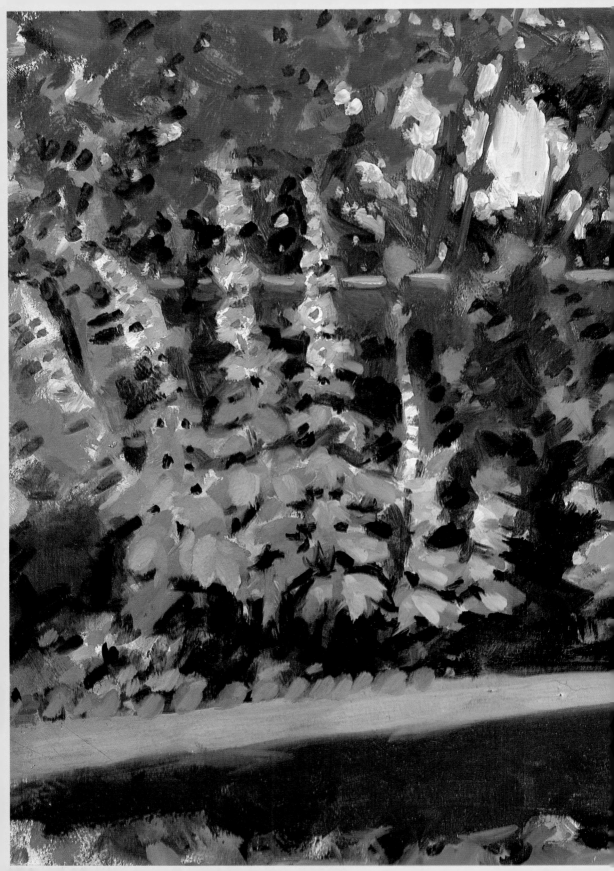

III. FLOWER PAINTINGS

HOLLYHOCKS
1983, oil on rag board
12" x 12" (30.5 x 30.5 cm)

CLOSE OBSERVATION

My paintings of flowers are meant to be fairly modest and straightforward paintings, sketches really, and their presentation is, consequently, pretty simple. The way a subject looks has a lot to do with how I decide to present it. Since I'm not painting an emblematic, iconic symbol when I paint a flower (Botticelli's trees and flowers, for instance, were often stylized), but a natural object as found in nature, I avoid an overtly structural approach. Instead of forcing the flower into a composition, I let its form suggest the design. You'll notice, on close observation, that the logical symmetry of an ideal tulip or daffodil is never duplicated in an actual tulip or daffodil (even one in the flower of health). There are always deviations from symmetry, bulges, leanings, and whatnot, that individuate organic forms. Far from being "flaws," such imperfections are, from a painter's point of view, often the most interesting thing about a plant. When you're painting "flaws," and oddities of shape, you can be pretty sure that you're getting closer to seeing what's really there, and further away from your preconceived idea of how it should look.

Occasionally you will find a plant as weird as doll's eyes,

which is odd enough to benefit from an absolute straightforwardness of approach. The same is true for the angel's trumpet, a strange and elegant flower, and the poker plant. Such plants are good to paint, since they are so interesting in and of themselves that it is enough simply to concentrate on getting down what's there.

The important part is careful, concentrated looking. When Frederic Church and other great nineteenth-century American landscape painters made small studies from nature, as they often did, the results were quite different in intention and effect than their easel paintings. Grand ideas were saved for the studio. They got out and looked, to keep the eye fresh and alive.

Again, these flower paintings were conceived as studies, and they retained the looseness and offhand quality of observation. It's always important to me to avoid making a painting seem too precious, and these flower paintings, in particular, should not be viewed as too much more than exercises. I find them useful to my other work, and painting one always serves to remind me that a painter needs to learn more about what's out there—how to see it, and how to paint it—every day.

DOLL'S EYES
1985, oil on rag board
10" x 8" (25.4 x 20.3 cm)

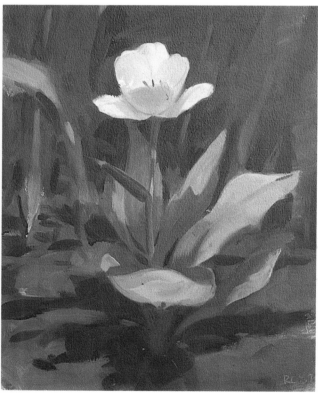

YELLOW TULIP
1985, oil on rag board
10" x 8" (25.4 x 20.3 cm)

AUTUMN ROADSIDE
1985, oil on rag board
10" x 10" (25.4 x 25.4 cm)

I liked the Indian corn range of colors in this bank of land. It had been cleared when a road was built, and subsequently allowed to go wild again. In painting this, I was careful to observe not only the texture of things, but the affect of focus on texture. Notice how the leaves of the trees at the edge of the woods—which wasn't really so distant—were left very generalized, without much suggestion of texture, because the focus of the painting was on the foreground shrubbery.

CATTAILS,
SULLIVAN FIELD
1980, oil on canvas
12" x 14" (30.5 x 35.6 cm)

*This is a small, intimate painting where you're right down in the
landscape. I was examining the cattails fairly closely, looking at
their structure from close-up, as a break from the big panoramic
landscapes I had been painting.*

MULLEINS
1981, oil on canvas
14" x 18" (35.6 x 45.7 cm)

I was looking specifically at plants as particular examples of their species and was also interested in them for their abstract, vertical forms. Mulleins have a unique presence and personality in the landscape.

BINDWEED
1981, oil on canvas
14" x 18" (35.6 x 45.7 cm)

In painting this I was thinking about the landscape of full summer, and the plants that grow in abandoned fields: bindweed, mullein, and scrubby trees. This was an abandoned garden site. I liked the profusion of different kinds of plants.

LANDSCAPE AS STILL LIFE

I began to paint flowers in my backyard, just for my own amusement. A few years ago, a friend from Seattle sent me some pink and white hollyhock plants, which my wife and I successfully transplanted in our garden. I was so pleased when the plants grew and bloomed, that I took a few prepared rag boards and the French easel outside to "knock off," or so I thought, a simple, quick study of blossoming hollyhocks. When I sat down to paint the first of what later became a whole series of small paintings of flowers, serious painting was far from my thoughts.

Painting nature at such a close range was quite literally an eye-opening experience. I realized, as I became absorbed in the process of painting, that this was a very different thing from our more generalized perception of deep space. I found myself working for the first time in many years on a one-to-one scale, and I was confronted by a specificity of information that demanded its own kind of approach. There is an almost overwhelming amount of detail in things seen up close, and the amount of detail that the painter can generalize seems to decrease as the object gets nearer.

I had painted a few landscapes at a closer range before—a painting of a stone wall here, a railroad embankment there. I particularly liked some studies I had painted of sumac, a wild shrub that is plentiful in Virginia. When I first moved to Charlottesville to teach at the University of Virginia, I lived in a small apartment, and one of its windows looked out onto a backyard full of sumac. The tangle of leaves made an exciting visual complexity, which I thought would be a challenge to paint. The challenge was to find a way to simplify a mass of complex texture enough to be able to paint it, and at the same time keep it complex enough to make the painting worthwhile. This was no easy job, and I painted the sumac several times over a period of months before I felt satisfied with the results.

Where in studying the sumac I wanted to make an interesting painting out of what was essentially texture or background material, in painting flowers my thought was to look at a subject and keep on looking until I got a fair representation of everything but the background. I had painted the sumac bushes from up close, but had still managed to keep the subject at a reasonable distance—say fifteen feet—where it was visually at bay, despite its complexity. Now I was faced with an apparently simple subject, a leafy stem and a few flowers, which demanded the special skill of a still life painter.

The first few flower studies I made demanded the most objective painting I had done in some time, and it was quite exciting to discover what was, for me, a whole new area of landscape painting. I felt well challenged by the demands of something as simple as the texture of light across a petal, which called for the touch of a figure painter. I soon saw that, besides the obvious link this kind of close, studious painting had with the still life genre, there was also a parallel with

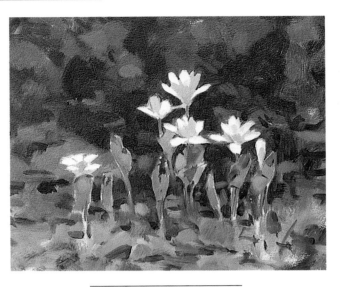

BLOODROOT
1986, oil on rag board
8″ x 10″ (20.3 x 25.4 cm)

figure painting. When you paint the figure from life, what you see is as important as what you know. In fact, painting petals is quite a bit like painting flesh: you find the same need for attention to texture and light, and the same uncanny subtlety of color gradations. In other words, it can all turn to mud very quickly if you don't know what you're doing.

I became fascinated with the idea of making small, focused paintings of flowers on a one-to-one scale. Besides the challenge involved in exploring a new area of painting, it was also a chance to have my work complement my wife's interest in gardening. We have a small garden, but it is blessed with an odd variety of plants, thanks to our raids on the woods (we've transplanted more than a few of our favorite wild plants to the back and side yards). Once I began painting flowers, only autumn could stop me. I painted flowers in various stages of decay, as well as in full bloom, and began to look closely at other "details" of the landscape.

It is always appealing to me if I think I can find unexpected interest in something entirely commonplace; or, better yet, in something usually thought of as "ugly," or just not worth looking at. Good painting can very quickly override our inclinations about what is and isn't worth looking at. It's often an interesting challenge to prove to yourself, and, one hopes, those who look at your paintings, that something really is worth the attention. An extreme example of this aesthetic: amid cries of "Why on earth do you want to paint that old thing?," I painted a study of the rusted-out oil barrel that my mother-in-law burns trash in. While not properly a flower painting, I think of it as an outgrowth of the flower series, and another one of my attempts to penetrate the mysteries of the ordinarily ugly. (Not that it proves anything, but the painting did sell.)

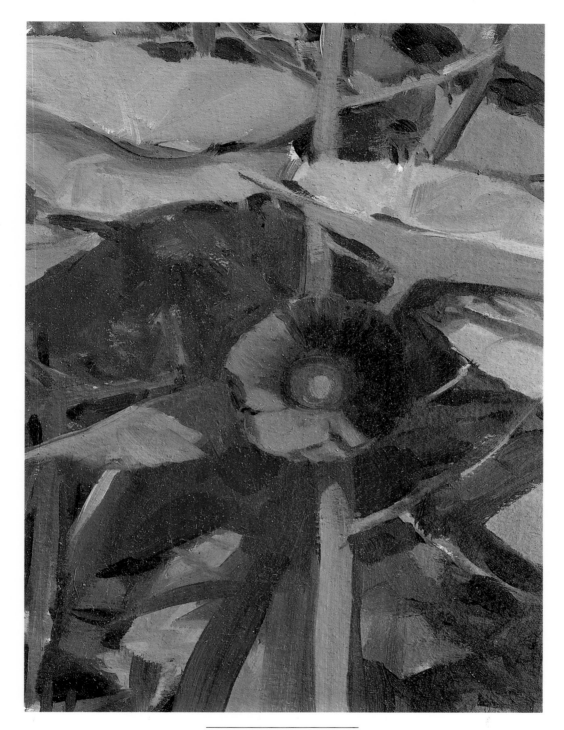

HOLLYHOCK STUDY
1985, oil on rag board
7" x 5" (17.8 x 12.7 cm)
Collection of G. Remak Ramsey
(reproduced larger than actual size)

Painting this hollyhock flower partially in shadow, I was interested in the way the light came through the big umbrellalike leaves. The colors of the leaves—a chalky gray-green and a cooler bluish green on top; a gray-blue-green and a warm yellow-green on bottom—played off nicely against the blue shadows and the deep burgundy red petals. *I often ask myself,* What color am I looking at really? What color is it in shadow? What color is it in light? *You have to keep the light consistent throughout.*

TULIP LEAVES
1985, oil on rag board
8" x 10" (20.3 x 25.4 cm)
Collection of G. Remak Ramsey

These tulip plants that came up from the ground, with their buds still folded in, formed beautiful sculptural shapes. I was looking carefully for color: there is always more than you see at first in a color that appears to be flat. Even when you look at a white wall, it will be modulated because of reflections, light, and textures. Finding a thing that is truly one color is quite difficult. Another thing that interested me was the way the buds go from a warm pink to a cool green. Making a smooth transition from a warm color to a cool color, between two complements, is quite difficult. You run into some extremely difficult and ambiguous colors.

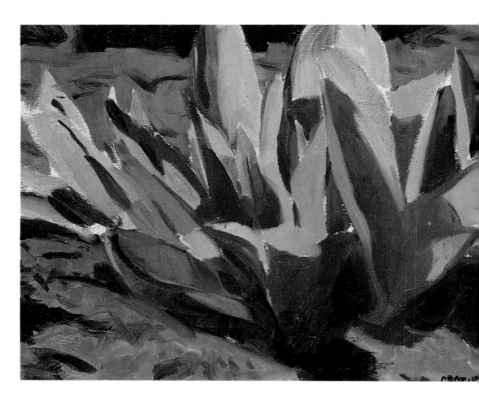

10TH OF MARCH
1984, oil on rag board
10" x 8" (25.4 x 20.3 cm)
Collection of G. Remak Ramsey

I chose to paint these very young daffodils when they were just coming out of the ground. At this stage, their forms are a little clearer—easy to comprehend, and easy to paint quickly. Flowers are always changing colors in the process of growth, so I was careful not to assume too much—I looked for what was actually there.

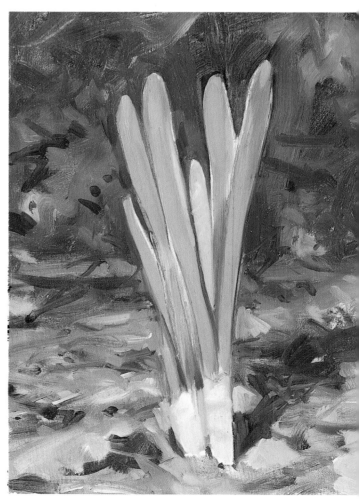

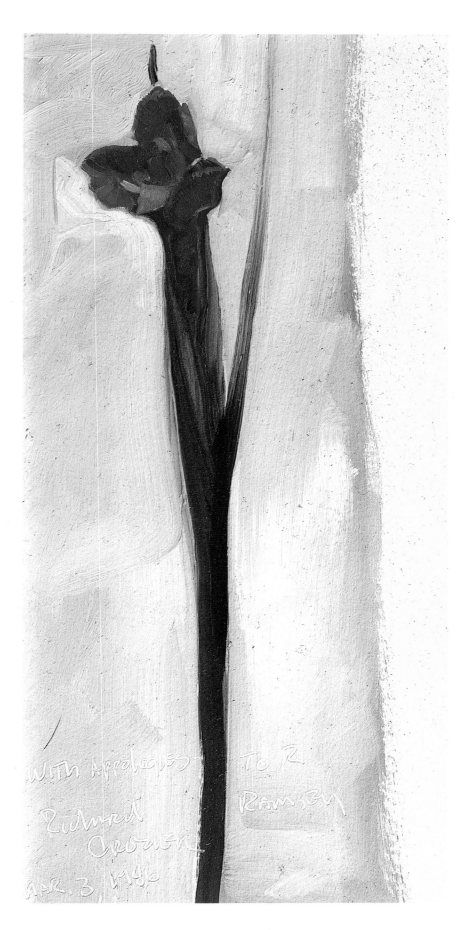

DUTCH IRIS
1986, oil on rag board
9″ x 4″ (22.9 x 10.2 cm)
Collection of G. Remak Ramsey

This was actually a cut flower that I brought into the studio and painted under artificial light—something I rarely do, and I think it shows in the color and in the handling of the plant. I was interested in the specifics of the anatomy of the flower, looking at it closely, and also trying to make the white background as important as I could to the shape of the flower (as I painted the white upward, it either hardened or softened an edge). You harden an edge to make it prominent, to bring it forward, and soften it to move it back into space. It's like a crude atmospheric perspective at a very close range, but it's effective. I was also trying to keep the brushwork in the background interesting, and make it relate in some way to the feel of the flower. Otherwise, I would simply be filling in a background.

WHITE HOLLYHOCKS
1985, oil on rag board
10″ x 8″ (25.4 x 20.3 cm)
Collection of G. Remak Ramsey

Here is a study of some white hollyhocks, just opening. Seeds were forming in the seed pods, and the leaves were old and beginning to brown around the edges. It's a plant in decline. I was looking down into it, trying to feel out what kind of gesture the plant had. When they come up as sprouts, hollyhocks have a strong sculptural quality about them. As they get older, and accidents of nature happen to them, they take on a whole different personality.

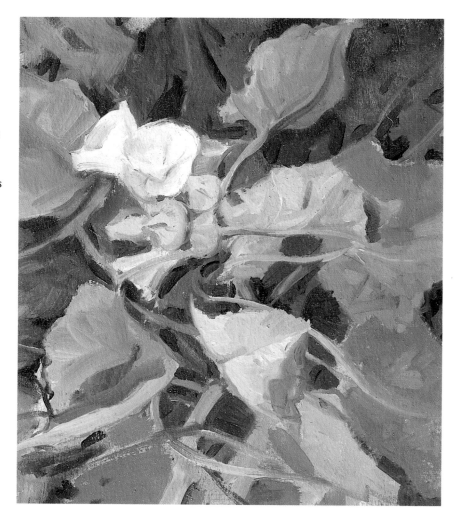

TRASH BURNER
1986, oil on rag board
8″ x 10″ (20.3 x 25.4 cm)
Collection of G. Remak Ramsey

This is an extremely prosaic motif for a painting: an old collapsed 55-gallon drum that's been used for a trash burner. Its coloring was quite interesting: the transition from light to dark, the ochre colors moving up through rust into almost a black. Because it was hollow and in the process of decay, its shapes interested me. It caught light nicely, and as a one-tone object against the cool grass, it created a dramatic color contrast. This is a thin painting, and I was trying to suggest texture with the mark of the brush, rather than describing it scrupulously. I allowed the actual ground of the painting to show through, and it functions as a color in the painting.

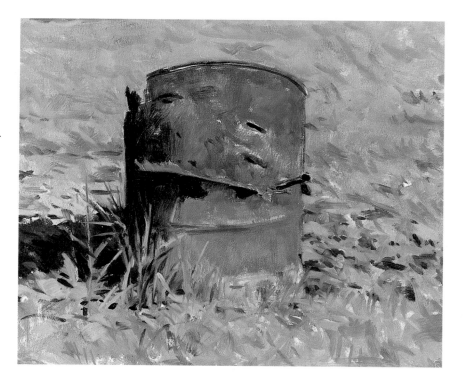

PAINTING WHAT YOU REALLY SEE

Everybody has an idea of how a flower looks and what color it is; anyone will agree that a daffodil is yellow. The trick is to see precisely how green a yellow, or to realize that half of the "yellow" is actually a purplish shadow. It's enormously difficult to paint something as you see it, because what you see is often influenced by what you know, or think you know—by preconceptions. You have to force yourself to ask the question, "What exactly is it that I see?"

After a half dozen paintings of hollyhocks, some of which got scraped off with a palette knife (a useful habit for most of us, I'm afraid), my eye fell on a somewhat dilapidated tulip. I found the splayed shape of the tulip visually arresting, so I painted it—about a forty-five minute sketch. I was still painting flowers rather loosely at this stage—the figure-painting analogy had not occurred to me yet. I was beginning to see that there were more possibilities to this kind of painting, with endless subjects close at hand. In retrospect, I think the tulip caught my eye because of certain contrasts in its structure: the smooth vertical of the stem seen against the relative complexity of the decaying organic shapes (horizontal for the most part), and the minute repetitions of its vertical axis in the style and stamens.

As the French philosopher Maurice Merleau-Ponty has pointed out, if you were to ask the landscape why it looks as it does, you would have to ask an infinite number of questions. In practice, you can only ask a few, but the more questions you ask as you're painting, the closer you get to the answers. It takes great concentration, and I know that my own facility for doing that can be limited. If you're not careful, you may find yourself falling back on painterly conventions, or on your own preconceptions.

If I had to concentrate on just one element to make a painting true to what I was seeing, I'd pick value. Value relationships are the essence of optical reality, and if you can keep them fairly true-to-life, the rest will usually follow. Color and the hardness or softness of the edges of things are also quite important. One of the things that often separates the amateur from the professional painter is whether the solidity and mass of objects is dealt with effectively, and this has a lot to do with the treatment of the edges of things (which are never as hard as they seem to be). An overall, perfect focus can be produced mechanically with a camera, but it doesn't happen in our actual visual perception.

Sometimes an odd thing may happen: you may be painting what appears to be there, and then you realize that it looks so odd that no one will believe your painting. Sometimes I have found myself making the things I paint less true to perception in order to make them more believable. This really comes from our limitations as painters. We might, for instance, get the color of the grass exactly right, but find it doesn't work with the rest of the painting because the value structure is off. This occurs when we haven't been able to ask enough questions about other things, such as the exact darkness or lightness of the sky in relation to a stand of trees. The question is then, "Am I going to throw the painting out, or make it work?" and the ultimate criterion of any painting is, of course, whether or not it works. The real art is not in making a supremely accurate picture of a given site, but a painting that works as a painting.

HOSTAS
1985, oil on rag board
10″ x 8″ (25.4 x 20.3 cm)

TWO TULIPS
1985, oil on rag board
8" x 12" (20.3 x 30.5 cm)

BLOODROOT, CLOSE-UP
1985, oil on rag board
12" x 8" (30.5 x 20.3 cm)

JACK IN THE PULPIT
1985, oil on rag board
10" x 8" (25.4 x 20.3 cm)

ANGEL'S TRUMPET
1985, oil on rag board
10" x 6" (25.4 x 15.2 cm)
Collection of G. Remak Ramsey

I painted this small study of an angel's trumpet bud in Berkeley, California. I picked out a flower that hadn't opened yet because its shape seemed so dramatic, exotic, and almost sinister. It's a good exercise to look at a white flower and find a lot of color in it. I was also paying attention to its surface anatomy, the delicacy of the flower, and the subtle detail that made it what it was.

NAKED LADY
1985, oil on rag board
6″ x 6″ (15.2 x 15.2 cm)
Collection of G. Remak Ramsey
(reproduced larger than actual size)

This tiny painting is a study of a bud coming out; the flower itself was painted life-size. I was very close to it when I was painting, looking at it as carefully as I could for color, shape, and anatomy. The flower is seen as an isolated object against a dark field because its shape, and the sculptural feel that it had, was so important that anything seen behind it would have detracted from it.

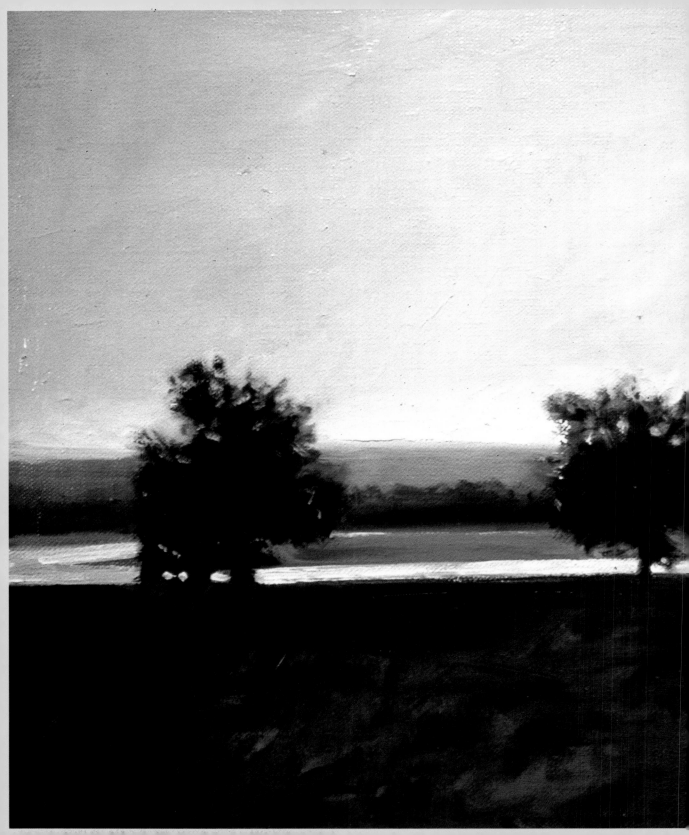

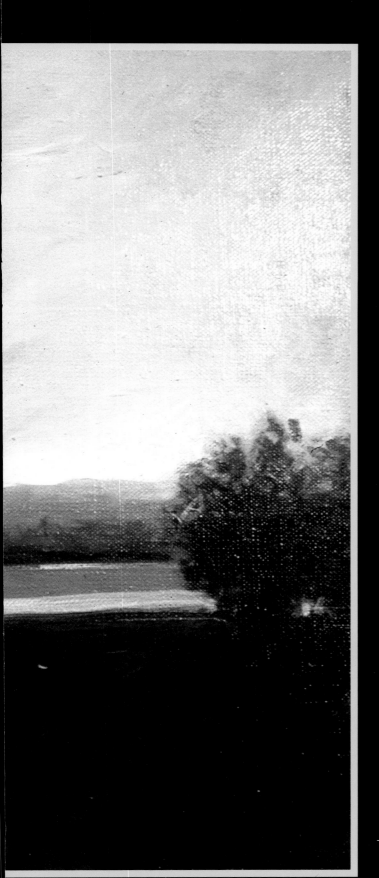

IV. PAINTING
ON THE ROAD

CALIFORNIA

There's a unique, silvery light in coastal California that you don't get anywhere else. The moisture in the air takes on a different color than it does in the East. The light gives the colors a subtler range, with less contrast and more intricate value relationships.

Since the light in California is very different from Virginia, when painting there I use an entirely different palette. I like that change, because it forces me to really look at what I'm doing and to think about it. You can get into certain habits when you're painting in an area that has become too familiar, and being in a situation which upsets those habits can be invigorating. You're forced to be a student again, not really knowing how to do what you're trying to do.

While studying at the University of California, Davis, I encountered a very different landscape than what I had been used to in Hawaii, where I grew up, and in Seattle, where I took my undergraduate degree. Davis is inland, flat and arid, with very little in the way of picturesque scenery, so I got into the habit of going out and finding things to paint. This helped me realize that what was interesting was the act and art of painting, not the subject. Anything can be made interesting by a good painter.

I've always had strong ties to the West Coast, and I try to get back there every year for a week or so to do some painting. In 1985 I spent six weeks in Berkeley, which gave me the chance to really focus on concerns that are particular to the California landscape. Some of my most successful paintings came out of the fresh looking I did during that extended stay.

CACTI
1985, oil on rag board
6" x 6" (15.2 x 15.2 cm)

I was looking closely at unfamiliar plant life in Berkeley, California. These dramatic plants caught the light beautifully; they're also specific and distinctive in their textures. Approaching them at random, I studied what they looked like, so I could understand how their textures contributed to the landscape.

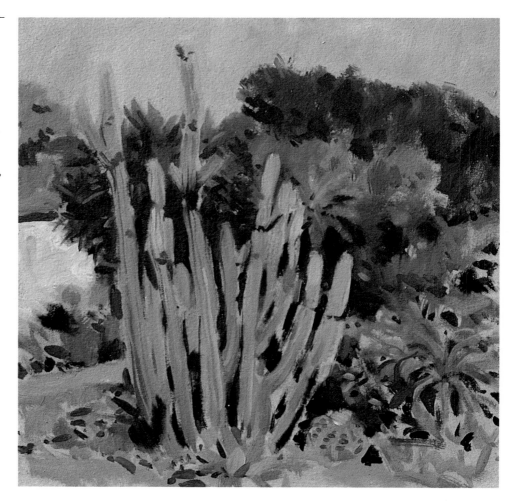

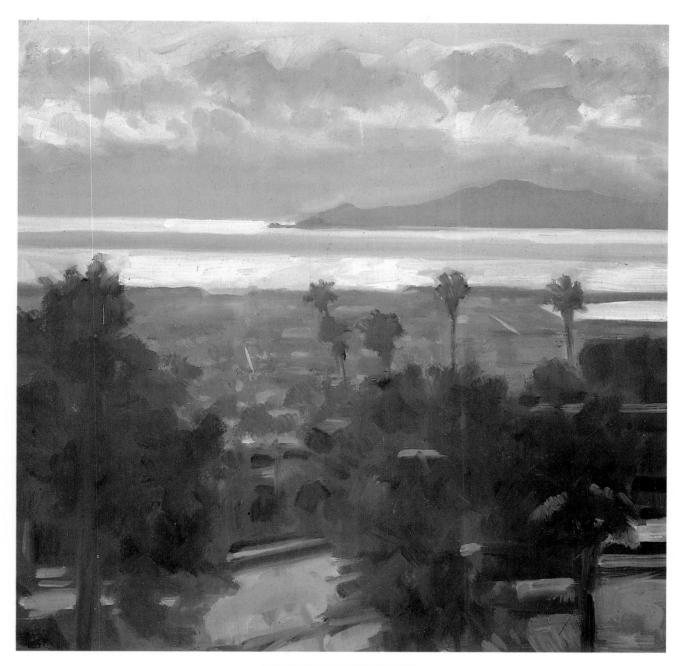

VIEW OF BERKELEY
1985, oil on rag board
9⅞" x 10" (25 x 25.4 cm)
Collection of Terrence Rogers

This is probably the best painting I made in California. The lighting is very complex, but there was no real plan to it. It was really in the process of painting that I arrived at this composition: through looking, painting, trying to react to what was there, and discovering the composition inherent in the landscape itself. I had looked at Berkeley a lot, so it wasn't hard to know what it was I wanted. Having passed that site a number of times, one day I parked my truck on a steep street, climbed into the back, and painted from there.

There is a magical quality to this painting—it has that silvery tone you really do see out there. But what really makes the painting work is the subordination of detail to light. That's a difficult thing for painters to understand, and I see that misunderstanding in the work of many painters who feel compelled to force detail into everything: such a painter would put windows in all the buildings in the town and destroy the feeling of light and atmosphere. Sometimes you have to give up details in order to let the painting work as a whole.

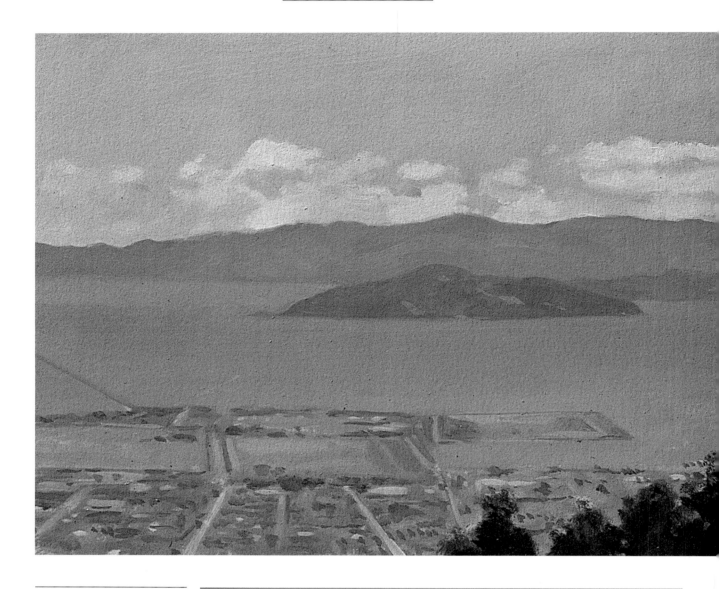

MOLATE BEACH
1985, oil on rag board
6" x 8" (15.2 x 20.3 cm)

This is a funny little island in San Francisco Bay: dome-like and red in color, it made a nice contrast against the water. I couldn't resist painting it.

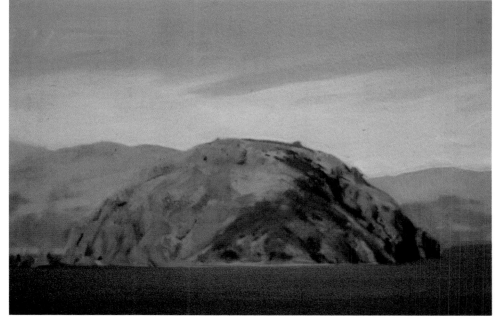

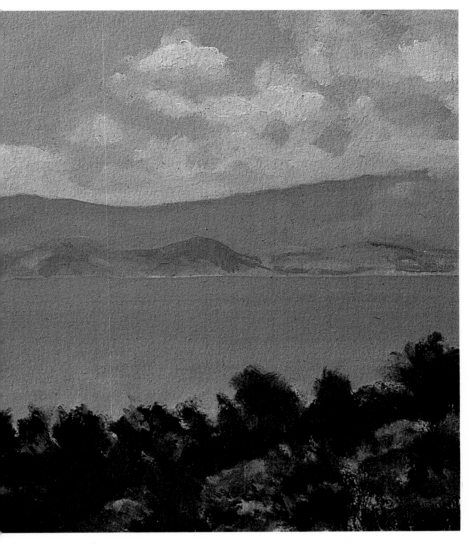

SAN FRANCISCO BAY
1985, oil on canvas
8" x 18" (20.3 x 45.7 cm)

I painted this looking out over the city of Berkeley, toward Angel Island and Marin County, from up in the hills behind Berkeley. I was trying to get the color of the bay—an unusual aqua color— and the sense of distance from looking out over a great space. I was trying to suggest the complexity of the city grid in the foreground without really having to paint individual details. I had to develop a color and a texture that would be convincing without being specific.

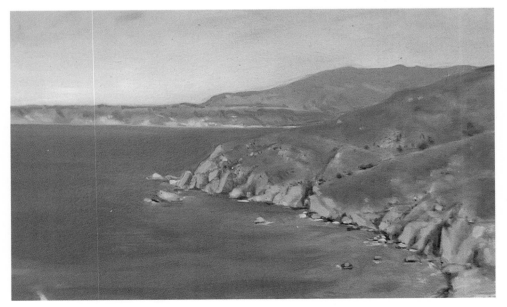

MARIN COAST
1985, oil on rag board
7½" x 12" (19.1 x 30.5 cm)

This painting was an attempt at a different subject—I'd painted very few seascapes, and I was fascinated by the colors of the tawny brown soft hills against the deep blue water. It's important to keep trying new and different motifs, to keep testing yourself against things you're not sure you can paint.

STRAWBERRY CANYON
1985, oil on canvas
16" x 12" (40.6 x 30.5 cm)

California has a unique kind of light: it turns silvery in the moist, dense coastal atmosphere, and it makes you very aware of shadows and backlighting. It's a little hard to pin down the difference in light between California and Virginia to the landscape painter—the light in central Virginia seems yellower, warmer, where the silvery brightness of the California atmosphere seems to give an enveloping sheen to colors.

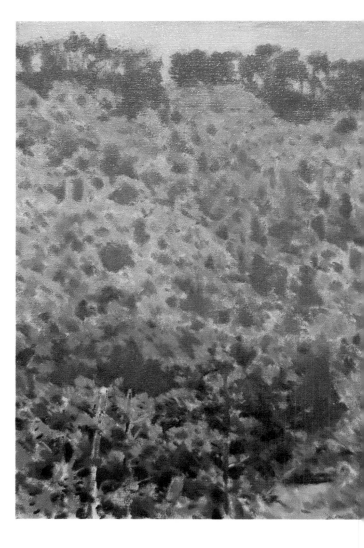

OAKLAND FROM
GRIZZLY PEAK
1985, oil on canvas
8" x 10" (20.3 x 25.4 cm)

This painting was an attempt to work with an extreme atmospheric perspective. The city of Oakland, which read from that particular distance as a complex texture, was laid out in the flat areas below me. I was looking down off the side of a hill, and I tried to suggest the fact of a great deal of activity, complexity, and texture in a subtle way—to keep it looking as though it were at a great distance. I was careful to keep the values extremely close: to identify the color I was painting, and then work with only the slightest tonal variations of that color.

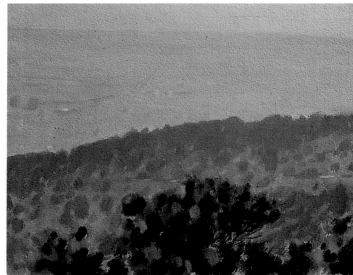

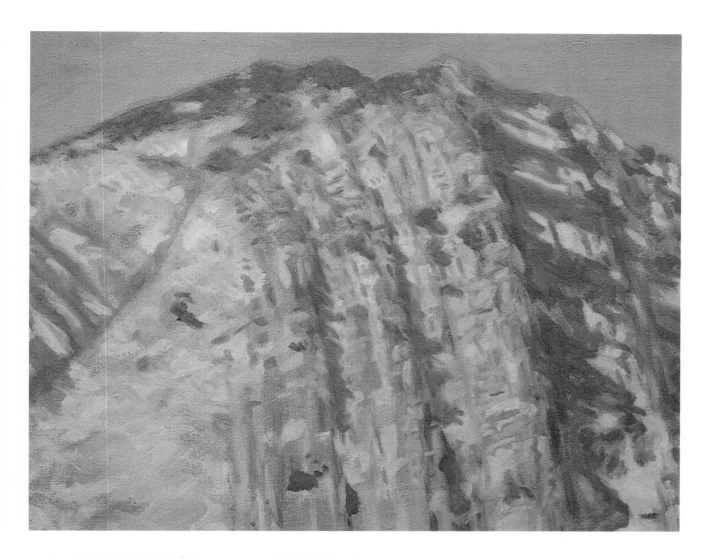

COAST HILLS
1976, oil on canvas
14" x 18" (35.6 x 45.7 cm)

I was attracted to this site by its dramatic geological formation, which was unlike anything I'd ever tried to paint. The hill just filled the canvas. Painting the textures of the rocks was a challenging and satisfying problem.

PALMETTOS, BERKELEY
1985, oil on rag board
8" x 10" (20.3 x 25.4 cm)

I enjoy painting an exotic landscape, and California is exotic for me. Palm trees catch light in a specific, beautiful way. I'm fascinated by the interesting textures in their trunks.

THE SOUTHWEST

I have visited the Southwest at different times over the past five years. Frequently I'd simply park my truck, set up the French easel by the road, and see what I could do with the unfamiliar, sometimes spectacular views I encountered there. As always, the unfamiliarity of a new landscape made the process especially stimulating.

The dryness of the Southwest produces an astounding clarity of vision. You can see trees twenty miles away, and you have a different kind of focus than you do where the atmosphere is hazy and visibility is limited. The lack of moisture in the Southwest air allows the true colors of the landscape to come through, even at a great distance. Things near the horizon are usually less blue, and a little yellower, than in parts of the world with more humidity.

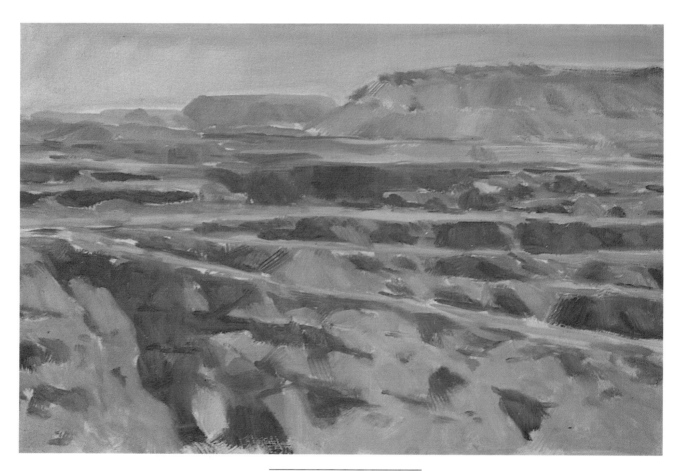

LAVENDAR PIT,
BISBEE, ARIZONA
1987, oil on canvas
10" x 15" (25.4 x 38.1 cm)

This enormous hole was cut into the ground over many, many years of getting ore out: it made ridges, unnatural but at the same time a fascinating landscape. A large excavation is an unusual event in the landscape: something unexpected, unnatural, and therefore eye-catching. The color of the rock was striking: a deep red-brown, almost purple (Lavendar does not refer to the color of the rock but to the name of the man who owned the company). As always, I was looking at color changes, textures in the rock, and how light picked textures out and emphasized them.

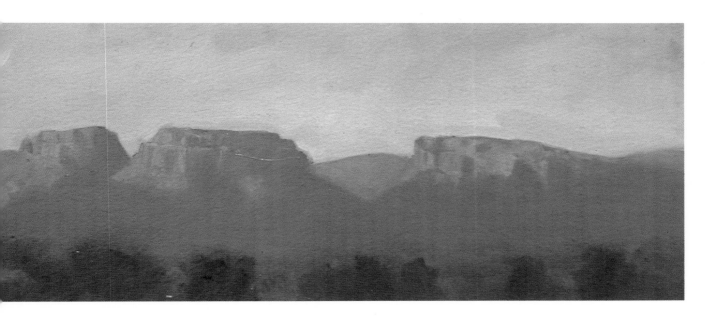

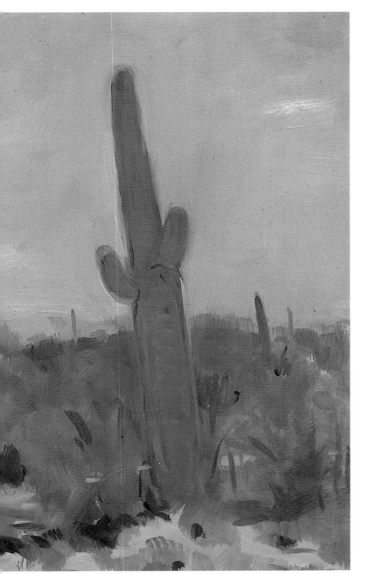

KINGMAN, ARIZONA
1985, oil on rag board
4″ x 10″ (10.2 x 25.4 cm)

This small painting you could just about send through the mail as a postcard. It was actually done in a slightly different way than I usually work. I often start small paintings without any drawing: I'll just start putting color down on the canvas or the board. On this one I was in a great hurry, since the sun was going down, and I just pulled into the motel parking lot. I took a ball-point pen and scratched out as much as I could in a few minutes on the rag board (which, luckily, was already prepared). Then I took the board inside and painted it under artificial light in the motel room. I was not particularly pleased with it when I did it, but when I looked up the next morning, I realized I'd done a pretty good painting. I think the process of painting away from the motif forced me to simplify the picture, and to create a monumentality that was suited to the subject.

SAGUARO NATIONAL MONUMENT
1987, oil on canvas
15″ x 10″ (38.1 x 25.4 cm)

I drove up to the Saguaro National Monument because I wanted to see what enormous cacti looked like, and I spent a day or so in the park painting them with varying degrees of success. I was trying to emphasize the roughness of the land, the texture of the foliage, and the way in which the cacti almost activate the landscape, as if they were figures standing in it.

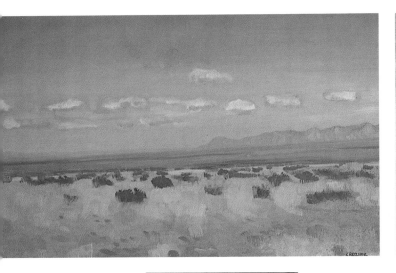

OPEN DESERT
1987, oil on rag board
10" x 15" (25.4 x 38.1 cm)

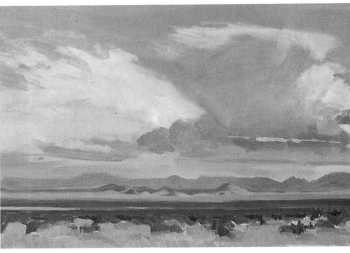

THUNDERHEAD
1987, oil on rag board
10" x 15" (25.4 x 38.1 cm)

DESERT, ARIZONA
1987, oil on rag board
10" x 15" (25.4 x 38.1 cm)

**SNOW,
HUACHUCA MOUNTAINS**
1987, oil on rag board
10" x 15" (25.4 x 38.1 cm)

I did this group of paintings within a few hours or a few days of each other. When I was out in Arizona, I usually did about four paintings a day, two in the morning and two in the evening. I was discovering a different palette and dealing with a different light, a different clarity of atmosphere. It was difficult finding ways to express enormous distances without using my usual bag of tricks. I had to find out how colors were affected by the light of that clear atmosphere, where it would be easy to make things look like they were entirely too close by. My brush marks had to be modified to accommodate this.

There's a lowness, a scrubbiness to the desert floor, and in order for me to paint the distances involved effectively, I had to work with close values. I tried to get a sense of color into the landscape without making it too strong: a precise modulation of color, mark, and values. I was trying to learn something about that landscape.

LATE AFTERNOON
RAMSEY CANYON
1987, oil on rag board
10″ x 15″ (25.4 x 38.1 cm)

CLIFFS, RAMSEY CANYON
1987, oil on rag board
10″ x 15″ (25.4 x 38.1 cm)

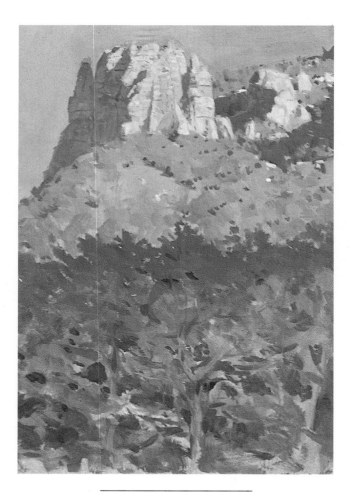

OUTCROPPING,
RAMSEY CANYON
1987, oil on rag board
15″ x 10″ (38.1 x 25.4 cm)

This series is a group of studies of rock outcroppings in Arizona. I was looking at them for the way that they reflect light, and the potential they have for a dramatic presence in the landscape. I was also trying to get a sense of their enormity—of how large those rock outcroppings really are. These studies involved a lot of drawing with paint (there is no charcoal or pencil under them). I simply began by putting down color, using a sable brush and a fairly thin medium. I used a medium of stand oil thinned with a little turpentine (I occasionally add some Damar varnish to that mixture, but not much). The medium let me work quickly, wet into wet, and allowed me to do some over-painting, which was necessary to refine edges and suggest detail. I roughed out the light and dark faces of the rocks, quickly scrubbed in color, suggested texture, and got down the major divisions in the landscape. By simplifying what I saw, I was able to finish the painting on the spot and still have a pretty good record of what I'd seen.

WYOMING

There's a variety of landscape in the great western region, ranging from extremely flat, monochromatic prairies to almost volcanic deserts to mountain ranges like the Bighorns. While I haven't made prolonged stops in Wyoming, on the brief visits I have made, I was impressed with the clear atmosphere, the pastel colors, and the strong extremes of light and shadow.

The western landscape is in itself dramatic; a painter is confronted with either the drama of deep space or the extremes of geology, enormous upthrusts of rock and mountains. In a state like Michigan you really have to look to find an interesting subject, but the western landscape is so dramatic that there is almost too much subject, which can be overwhelming.

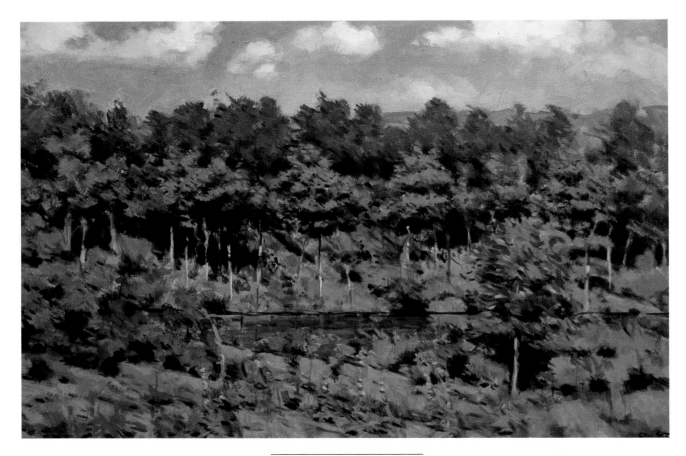

POND AT RUPPERECHTS
1983, oil on canvas
16″ x 20″ (40.6 x 50.8 cm)

I don't think anyone would guess that this rather anonymous site was in Wyoming. It's not your typical western landscape, with dramatic rock formations or mountains. There's a familiarity to the landscape, which can be found in many parts of this country.

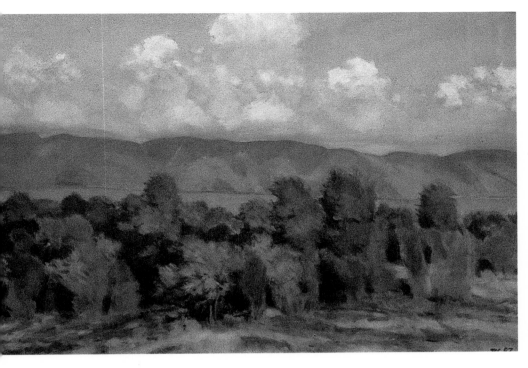

BIGHORN MOUNTAINS
1981, oil on canvas
16" x 24" (40.6 x 61.0 cm)

This was painted looking up at the Bighorn Mountains from the town of Big Horn, near Sheridan. The mountains form a wall almost like a curtain against the flat, dry prairie. It was strange the way those big monumental mountains were simply inescapable. The sense of scale is really enormous in that part of the country. The configuration, surprisingly, is similar to the way the Koolau Mountains come down behind Honolulu—just an abrupt wall of mountains that cut off the landscape.

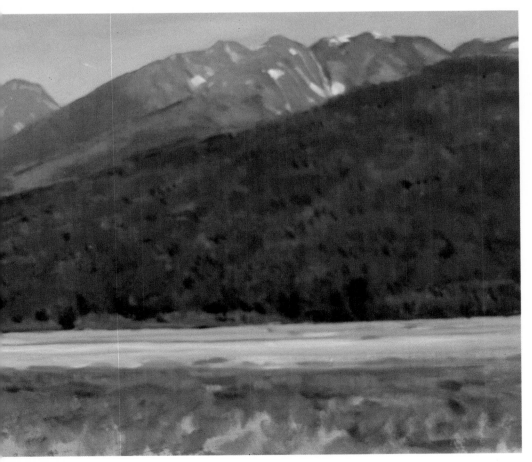

GRAND TETONS
1985, oil on rag board
8" x 10" (20.3 x 25.4 cm)

This is a small study of the most spectacular mountains in Wyoming. I was looking for motifs I hadn't tried before, such as the large masses of rock, the change in atmosphere, and the low, barren expanse of the river plane.

MICHIGAN

I visit Michigan in the late summer every year, to see my in-laws. Michigan is very green, rural, and clean. Because of its flat or gently rolling landscape, you're more aware of the sky, which tends to be dramatic. It's also a fairly subtle landscape; there isn't a lot there that jumps out and demands to be painted, so it takes a bit of looking around to find a subject.

Because of Michigan's unprepossessing geology, the inherent drama of space and distance becomes much more important. There are a lot of white birches—that are absolutely stark white—and on a sunny day the water is impossibly blue. Contrasts of light and shadow seem to be much fuzzier here than in the west, even though the air is extremely clear (the clouds are almost the same colors on the horizon line as they are overhead).

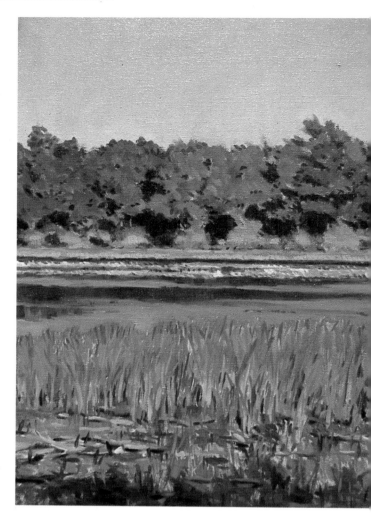

**LINCOLN LAKE,
MICHIGAN, AFTERNOON**
1985, oil on canvas
16" x 12" (40.6 x 30.5 cm)

I was looking at the brilliant reflections in the lake and the complex foreground of cattails, reeds, and swampy ground. There were a lot of reflections and textures; on the far side of the lake, the water lilies that were blooming made little spots of white. It was a difficult painting for me to do, but rewarding: like two paintings on the same board, the lower and the upper parts separated by an expanse of water seen through a clear, clean, northern atmosphere.

OSCODA, MICHIGAN
1984, oil on rag board
8" x 10" (20.3 x 25.4 cm)

This was a section of burned woods that had started to come back to life: the trees were blackened, but some green brush was beginning to grow around the bases of them. Some of the trees that survived were starting to leaf out again.

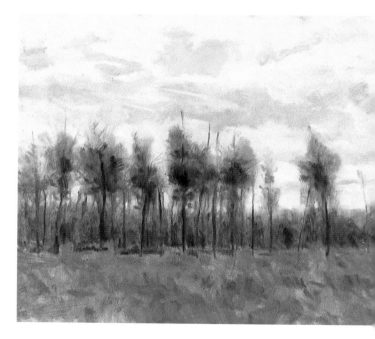

MASSACHUSETTS AND MAINE

In 1986 I spent the greater part of the year in South Hadley, in central Massachusetts. The landscape in Massachusetts is in many ways similar to Virginia—temperate deciduous forests and rolling mountains—but there is a different overall feel to the landscape, perhaps because the area had been glaciated at one time. There's also a different scale to the two landscapes. In Piedmont, Virginia, because of the verdant growth, you tend to feel a little more boxed in; you have a feeling that you're *in* the landscape a bit more. In Massachusetts it's easier to get out of and over the landscape, as I did in my paintings from Mount Holyoke.

I have also spent several months in Tenants Harbor, on the coast of Maine. A coastal region is very different from an inland landscape because of the moisture in the air, the bright reflectiveness of the water, and the way the structure of the land has been exposed by erosion. The constant wind flattens vegetation, and a kind of natural pruning takes place, so that the ground cover is thicker, closer to the ground, and follows the form of the land. In Tenants Harbor I had all the usual vagaries of weather that occur along a coast to deal with. It is also a fairly mountainous area, where I could get broad, panoramic vistas for many miles. Since rocks, cliffs, and the sea are all things I'm not accustomed to painting, there were fresh, challenging subjects everywhere I looked.

It's always a refreshing break for me to get out of Virginia for an extended time to paint another kind of landscape. When I return to Virginia, I'm often surprised all over again by the once-familiar scenery, and able to find something new to paint, or a new way of seeing the landscape.

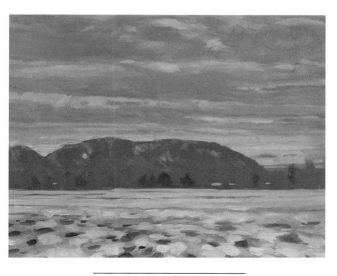

MOUNT HOLYOKE
FROM HADLEY
1986, oil on canvas
14″ x 16″ (35.6 x 40.6 cm)

One of the striking features of the landscape in this area is the Mount Holyoke Range, a series of abrupt and dramatic hills that rise up out of a more-or-less flat landscape. When I arrived in South Hadley, they immediately caught my attention as something I was going to involve myself with. I was looking at a lot of lighting conditions in different seasons, and I did a number of paintings of this and other similar motifs. Here, I was interested in the flatness of the snow-covered field, which became a series of horizontal marks as I looked out across it. The same horizontality was reflected in the dense clouds overhead.

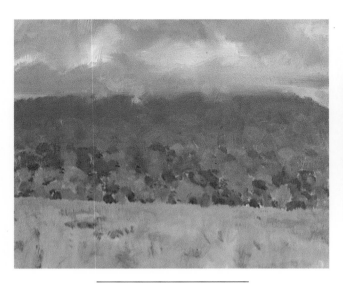

IN THE BERKSHIRES
1987, oil on rag board
8″ x 10″ (20.3 x 25.4 cm)

The affect of weather was enough of a subject for me: the mountain disappearing into clouds, and the soft, fuzzy fullness of the landscape in autumn.

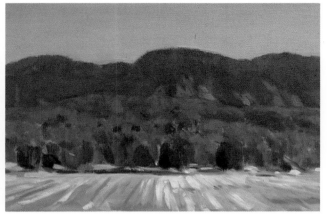

SEVEN SISTERS
1986, oil on canvas
12″ x 16″ (30.5 x 40.6 cm)

Seven Sisters is a name for the Mount Holyoke Ridge. In this very fast painting, I used the snow and its contours to create a ground plane rushing into the middle distance. I was trying to get down the dramatic light that was coming from the reflectivity of the snow, that feeling of clarity and luminosity.

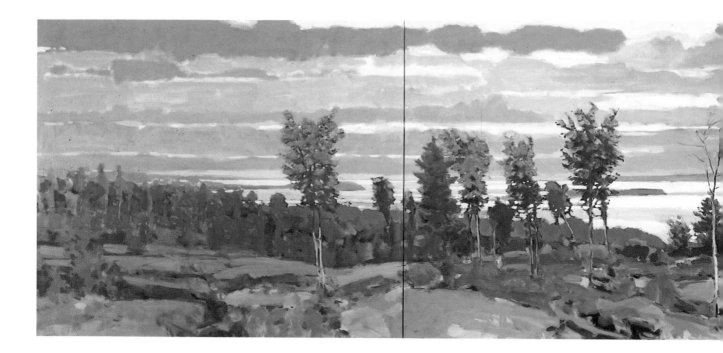

OWL'S HEAD
FROM MOUNT BATTIE
1987, oil on canvas
24" x 36" (61.0 x 91.4 cm)

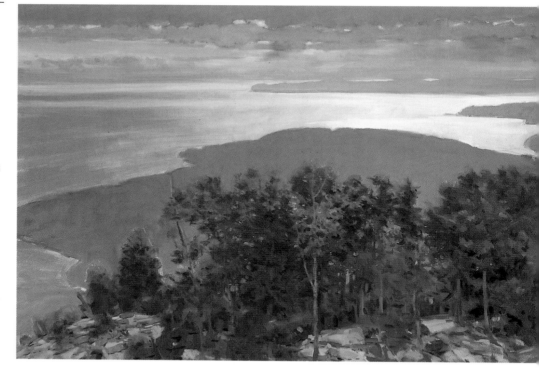

This is a painting based on a view in Maine. I'd done a couple of small paintings of it. The foreground was manipulated, but the background was faithful to the original view. I was interested in the reflections off the water and the shape of the coastline. There's an almost positive-negative reversal between the dark, dim coast and the bright, strong water. It seemed like a strong abstract element. I had to find other things to balance against this motif to keep it from becoming too overwhelming. I lavished attention on the trees in the foreground to try to make them solid and interesting enough to stand up to the background.

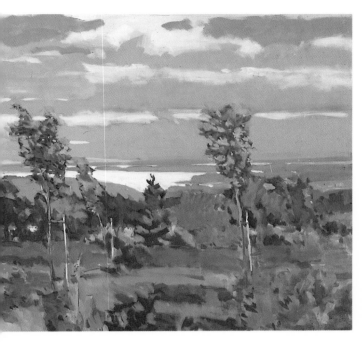

PENOBSCOT BAY VIEWED FROM MOUNT BATTIE
1987, oil on canvas, triptych
36″ x 120″ (91.4 x 304.8 cm)

This was the Virginia studio painting, Albemarle Grove, *reworked radically. The trees in the foreground are the same trees that were in the original painting, although the landscape has become something entirely different. This is a more radical reworking than I usually do, but I think the process, in this case, made for a happy conjunction between two different motifs. It was a case of punching out a different background, making it into a broad, deep space; then I just simply reworked the foreground—it was like grafting Virginia onto Maine.*

The feeling of a high, rocky area is what you would experience in Maine. The trees, which were invented trees, were painted as though they had just been planted, held up by little stakes and wired into place. I don't know why that idea always fascinates me, but I think it's an interesting thing—an odd conjunction between man and nature. In this case, I actually transported the trees to a place where they didn't really belong.

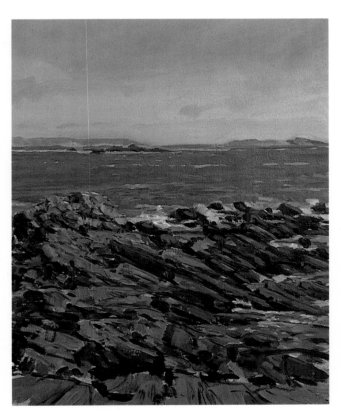

PROUTS NECK
1986, oil on rag board
10″ x 8″ (25.4 x 20.3 cm)

Prouts Neck was the site of Winslow Homer's studio, and knowing that he had painted the rocks that I was looking at was reason enough for me to sit down and try my hand at it. Obviously my results are different from his. This is a little study of the texture of the rocks. I was looking at the colors in the water, the value relationships, and the atmosphere out over the bay. When rocks are wet, they become reflective and shiny against the matte background of drier rocks. The change in colors was a problem that I had to wrestle with.

FULL CIRCLE: HAWAII

Since I grew up in Hawaii, its landscape is very familiar to me; but on returning to Honolulu after many years of painting in Virginia and California, its terrain felt exotic and presented a few problems. I'm no longer used to the light and atmosphere of Honolulu, with its constant atmospheric changes, which can range in the space of a few minutes from a moist, luminous atmosphere to one with a dry, almost desert clarity.

When I paint in Hawaii, I am continually aware of clouds, the constant activity in the sky from the trade winds blowing clouds across the sky, and the new clouds gathering over the mountains. Most of my Hawaii paintings were done from a building in Honolulu, on a twentieth floor balcony, looking out toward the mountains. My initial concern was in just having something to paint while I was visiting my parents.

My interest in trying to paint clouds began as a problem I set for myself. I made fifteen or twenty simple cloud studies—clouds, sky, and nothing else. I had to work rapidly, and finish a study in maybe twenty minutes, because the clouds were changing continually as I painted them. Clouds won't hold a shape for you, and you will find that their colors are surprising and much more complex than you might think. I looked carefully at the way the edges of clouds seem to work—whether they were hard- or soft-edged, whether they let the light through them or appeared solid, and whether they reflected light or color from the ground. Painting clouds was frustrating at first, but after a while I got the hang of it.

One of the things I found very unnerving is how blue the sky is when you're several thousand miles away from large land masses that generate a lot of pollution. I did most of these paintings looking up into the valleys behind Honolulu, at the ridges behind the city. I was looking specifically at textures: the suburban settlements up behind the city and in some of the valleys, and the different kinds of foliage on the slopes. At the same time, I looked for the textures the clouds made—going up over the mountains with the reflected light coming up underneath them, or settling into the delicate luminosity of the shadows of the valleys. The Hawaii paintings are full of evidence of the way light simplifies shape and form.

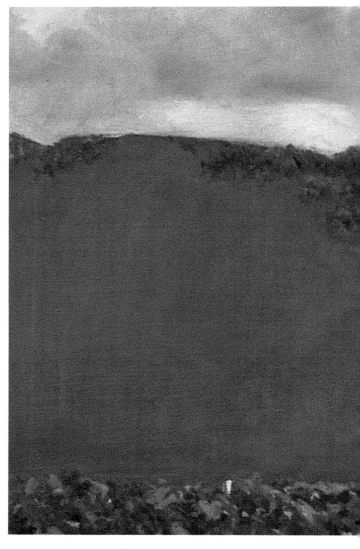

UNIVERSITY OF HAWAII
1975, oil on canvas
10" x 18" (25.4 x 45.7 cm)

The buildings in the extreme foreground are the University of Hawaii. I was using shadows to simplify texture—picking out textures in the city in the foreground, I played them off against a large, rather blank area of shadow in the middle ground.

PUU OHIA
1975, oil on canvas
10" x 14" (25.4 x 35.6 cm)

In this painting I was observing the way the hills behind the city captured shadows in their folds and ridges. The lighter foliage on the hills is a tree native to the islands.

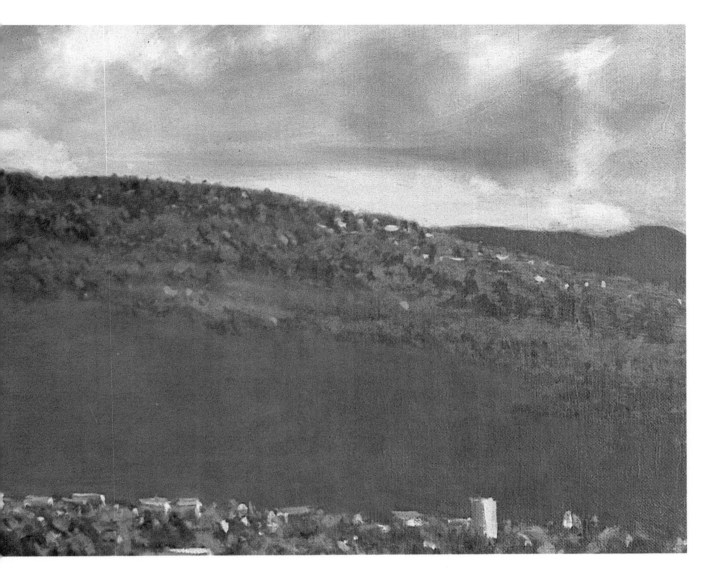

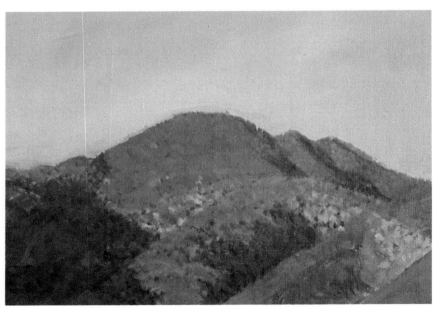

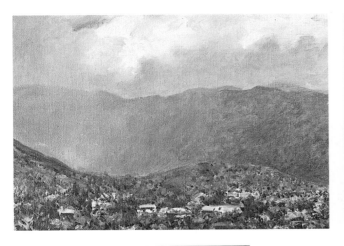

MIST, MANOA VALLEY
1975, oil on canvas
8" x 10" (20.3 x 25.4 cm)

This extremely atmospheric painting was an attempt to paint the abruptness of the shifts of distance in a mountainous, moist landscape. There is an abstract quality to the divisions in the painting; the foreground band of dwellings and foliage textures shift to distant trees seen through a haze, and then to a solid bank of clouds.

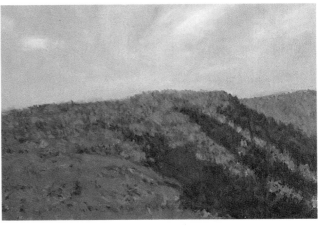

MORNING SHADOWS, MANOA
1975, oil on canvas
8" x 10" (20.3 x 25.4 cm)

I was watching clouds move across the valley, and their changing shadows. This study was simply an attempt to understand the exact solidity of the mountain I was looking at.

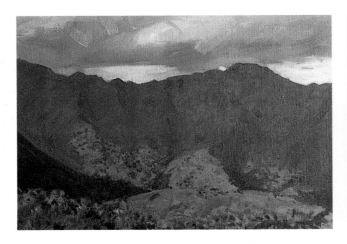

AFTERNOON, MANOA
1975, oil on canvas
8" x 10" (20.3 x 25.4 cm)

In this painting I was observing the changes in the color temperature in the afternoon clouds. They became much warmer, much redder than in the morning.

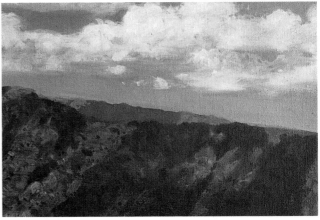

CLOUD SHADOWS, MANOA VALLEY
1975, oil on canvas
8" x 10" (20.3 x 25.4 cm)

I was fascinated with the cloud shadows, and the way they seemed to pour down the ridges and into the valley.

ABOVE PAPAKOLEA
1975, oil on canvas
8" x 10" (20.3 x 25.4 cm)

This is a simple study of clouds that were moving over a ridge top, casting shadows. There is a feeling of the clouds coming toward you.

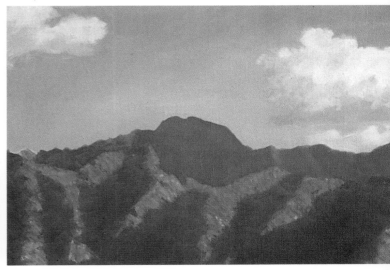

KOOLAU MOUNTAINS
1975, oil on canvas
8" x 10" (20.3 x 25.4 cm)

I was drawn to the dramatic crenulations and folds in the mountain ridges, which were heavily eroded, with thick vegetation growing on them. The strong blue sky set the mountains off nicely.

CLOUD ON RIDGE TOP
1975, oil on canvas
8" x 10" (20.3 x 25.4 cm)

Looking at the ridges disappearing up into clouds, I was exploring the contrast between shadow and light. These clouds were vigorously and quickly painted.

WILHELMENA RISE
1975, oil on canvas
8" x 10" (20.3 x 25.4 cm)

This was a suburban area in the Nuuanu Valley, with the back of the valley seen in shadow.

BACKLIT CLOUDS, HONOLULU
1975, oil on canvas
8" x 10" (20.3 x 25.4 cm)

This is a study where texture, light, and color are the important variables. I wanted to cram as many colors as I could into the mountains, from the complex and muddy reds in the foreground to the violets in the distant peak.

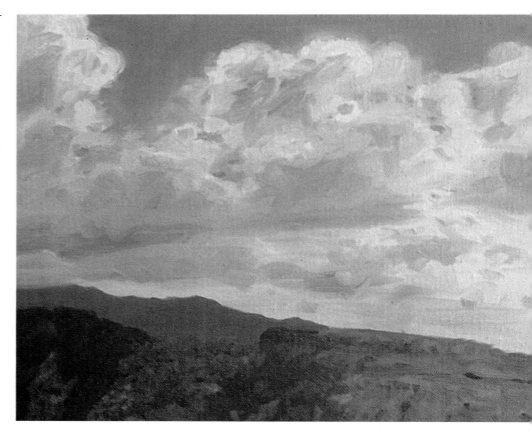

HONOLULU AND THE WAIANAE
1975, oil on canvas
8" x 10" (20.3 x 25.4 cm)

In this study of Honolulu there are a lot of new high-rise buildings. I had to integrate a lot of geometry into the natural setting.

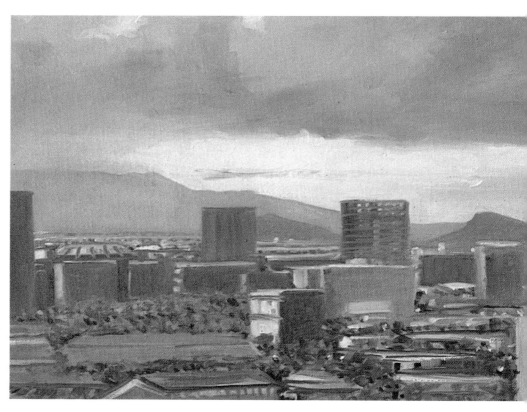

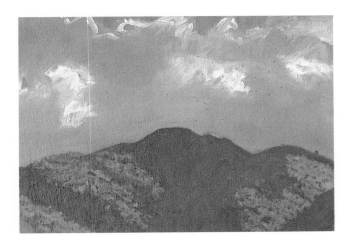

MOUNT TANTALUS
1975, oil on canvas
8" x 10" (20.3 x 25.4 cm)

Mount Tantalus is behind Honolulu, in a continually changing landscape of clouds and shadows. A landscape painter need never move from the spot where I painted this, because the light moves continually and changes everything. You could paint the same thing over and over and never be bored: the light is always changing, and when that happens, the color changes and the different features in the landscape are either picked up or obscured.

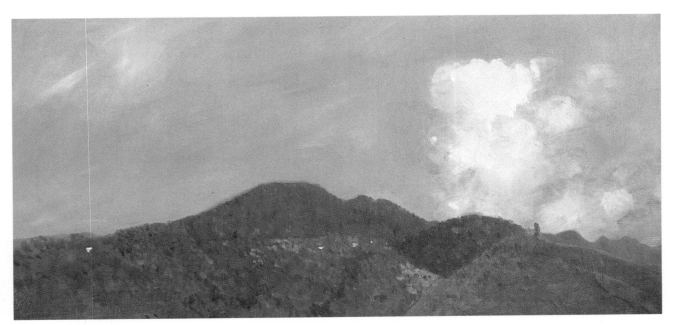

TANTALUS, LARGE CLOUD
1975, oil on canvas
10" x 18" (25.4 x 45.7 cm)

I have always liked the idea of doing a small painting on a panoramic scale. The size of a work need not restrain its inclusiveness of distance, nor the painter's choice of subject.

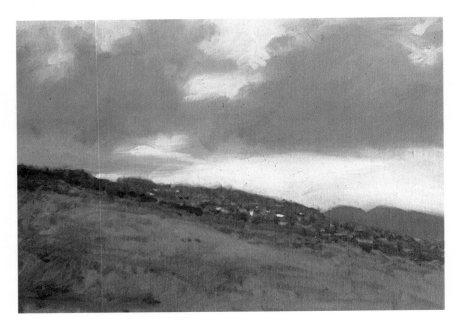

LOOKING EWA
1975, oil on canvas
8" x 10" (20.3 x 25.4 cm)

I was looking toward the town of Ewa, in the opposite direction from Diamond Head, up a tawny slope and at a building development on the side of the hill.

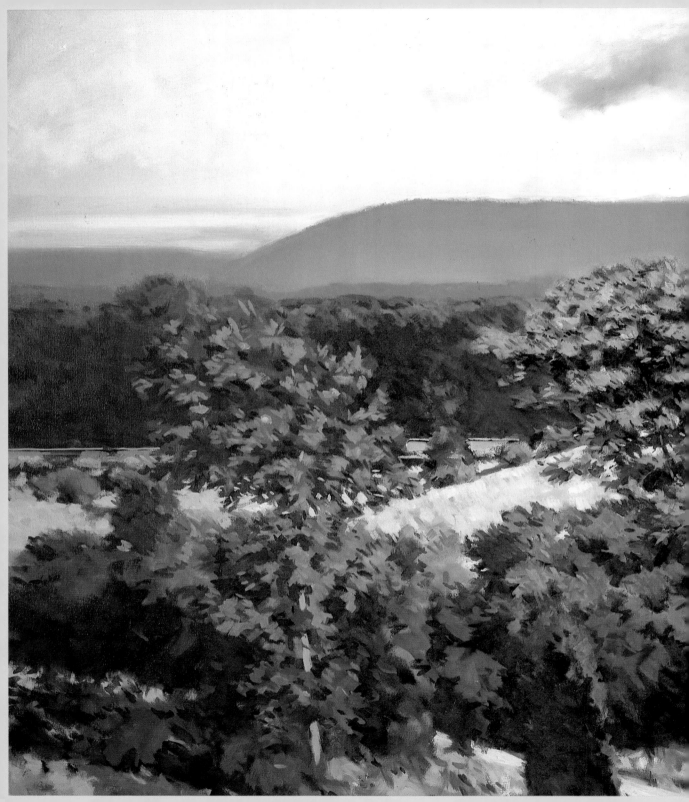

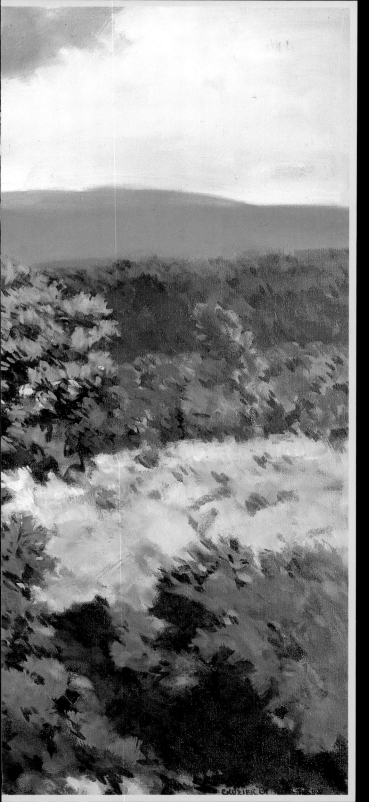

MIMOSA HILLSIDE
1981, oil on canvas
36" x 48" (91.4 x 121.9 cm)

INVENTION AS MEMORY AND IMPROVISATION

The part that memory plays in painting is one of my main concerns, and I think it has made my invented paintings more effective. When you paint from memory, you have had time to sort out the information: things that are not important are forgotten, and things that may be important are exaggerated or intensified. Paintings involving memory benefit from this process of clarification, as well as the familiarity with a landscape a painter develops over an extended period of time. I rarely work directly from my studies or photographs, because I want to have that process of memory at work while I'm painting in the studio.

My small paintings are seldom made with larger paintings specifically in mind. They are mainly attempts to learn something, or to work with some motif. In my invented paintings, I build off of my many plein air experiences, those sense-memories, without drawing on any specific site directly.

I sometimes begin with a bandlike, horizontal format. There'll be a foreground strip, a middle ground strip, a back-ground strip, and a strip of sky. This is not a formula for me, but a convenient way to establish a landscape space. In the process of painting I always progress from a fairly simple organization to a more complex one. A lot of things are attempted, and succeed or fail, before I consider a painting to be finished. A certain amount of improvisation, of working through trial and error, is a necessary part of the process of invention.

There is a major difference between painting something out of your head and painting something you are looking at. To start with, when you invent a painting, you need some compelling reason to paint a given subject; outside, the fact that a landscape is there in front of you can be reason enough to paint it. The two processes are very different. In the field you're responding directly to the stimuli that are right in front of you. There's an ongoing screening process, and since there's much too much detail to cope with, you have to make conscious or intuitive choices about what to exclude from the

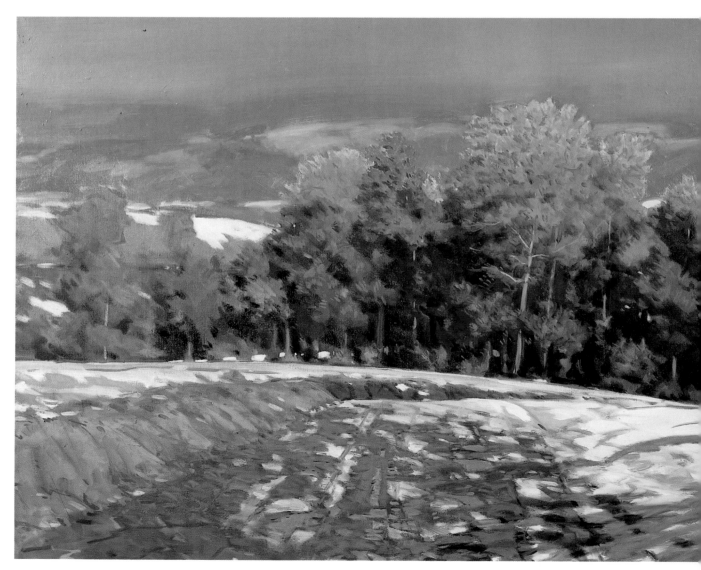

painting. In the studio, it's the reverse: instead of being a reductive process, painting becomes a purely additive process.

Often I'll begin with the most ephemeral vision, perhaps just a feeling. It's almost like trying to paint something seen in a dream—very difficult and elusive. I usually have a very strong visual idea about some place or time of day, perhaps just an impression, and with this in mind I'll start to draw on the canvas. I'll use, say, just one color in a thin turpentine wash, and simply work to get something down onto the canvas, a beginning. It's mainly a process of improvisation, not unlike the way in which an abstract painter of the more intuitive sort might start a painting.

When I start a studio painting, one of the rules I set for myself is to completely cover the canvas before I leave that first session. That way I'll have a completed statement of some kind on the canvas. I usually let that statement sit for a couple of days, come back, and begin to edit and change it. If I can come up with an invented landscape that ultimately convinces me of its reality, and communicates the sense of time and place I want to get across, then I figure it's finished. My larger paintings are done over a long period of time, there's always a lot of revision. I seldom end up with anything resembling the first sketches done on the canvas.

Sometimes I make radical changes in a painting, and I never know until the very end what the finished painting's going to look like. It almost never looks like anything I would have expected. Generally the idea you start out with is inadequate—something that can be visualized, but not painted.

You have to work until you can build something that can stand for that original vision on the canvas. It may not be the same vision at all, but it may have an equivalent strength and perhaps the same thrust. I like to think I really don't know where the images I construct come from. Each one is such an amalgamation of images that it becomes a concentration of years of visual experience into one work, and as such, more real than an accurate picture of an actual place could ever be.

NEAR NEW HOPE, VIRGINIA
1985, oil on canvas
36" x 60" (91.4 x 152.4 cm)
permanent collection of
the J. B. Speed Museum,
Louisville, Kentucky

The subject of this painting was a real event in the landscape: a large excavation, with tire tracks, melting snow, muddy ground, and a great deal of distance seen through trees. The far mountain with snow on it disappears into the sky. I was trying to construct a convincing winter atmosphere to suggest that kind of coldness. The idea for this painting came when, stopping just off the road near my studio, I saw an interesting excavation and made a quick pencil drawing of it. When I got back to the studio, I picked up an older painting that I was dissatisfied with and reworked it in light of these new ideas. I worked into the foreground and reinvented the background. I had the painting around for five or six years, just waiting for the inspiration I needed to finish it. In this case, just happening to see the right thing—that excavation I sketched—made something click in my mind, and I was able to make this painting.

BLUE RIDGE
1981, oil on canvas
14" x 24" (35.6 x 61.0 cm)

This was a conflation of ideas from my plein air paintings. I was trying to synthesize a painting from many of my individual experiences of looking at landscapes similar to this one.

NEAR VENTURA
1983, oil on canvas
48" x 60" (121.9 x 152.4 cm)

California's coastal light and its mountains are very dramatic and abrupt. The ocean moisture softens detail, and the California light has a compelling brightness about it, which I was trying to recall in this painting.

**FIELD OF GRAIN NEAR
SYRIA, VIRGINIA**
1984, oil on canvas
16" x 24" (40.6 x 61.0 cm)

I was after the feeling of summer in this painting: the heat and humidity, and the haze and moisture. This was started outside and finished in the studio, with a lot of work done in the studio. My smaller paintings depend largely on their freshness, so I was careful not to overwork this painting. I liked the visual pun with the textures of the trees in the middle ground relieved by the smooth Blue Ridge Mountains.

FLOOD PLAIN
1985, oil on canvas
24" x 32" (61.0 x 81.3 cm)

This loose painting is more painterly than most of my others. There is a pronounced brushiness to the cloud in the background. Thinking of the reflectiveness of water seen through trees, I painted over the water with thick paint, using a palette knife. Once in a while I need that for emphasis. I liked the sense of unsettled atmosphere and weather.

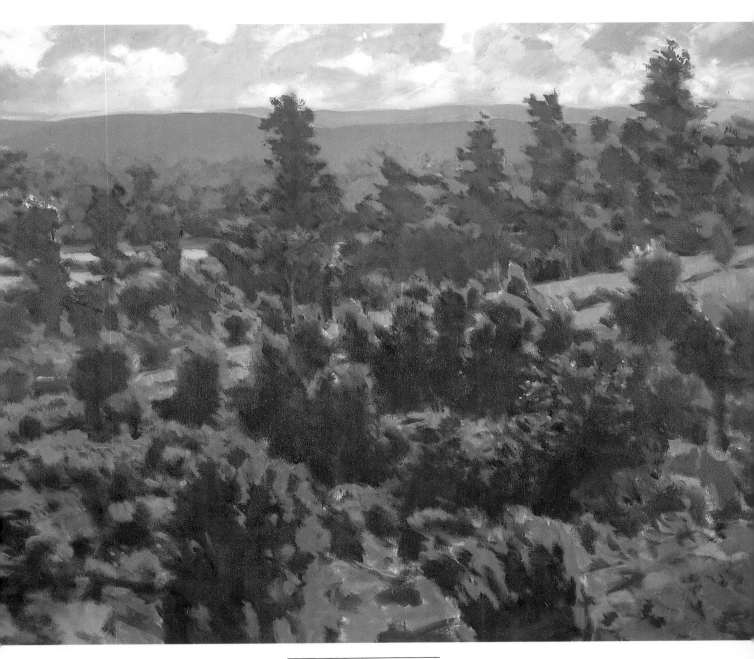

**BACKLIGHTING,
SPRING LANDSCAPE**
1984, oil on canvas
48" x 60" (121.9 x 152.4 cm)

This painting has some strange russet colors for a spring landscape, but one sees a lot of hangovers of winter well into the spring, before the grass greens out completely. That's the time of year I was thinking of here. You see days in spring that look like days in fall, and when the maple trees are in bloom, they're red-orange. I was looking for an excitement in the color. Working on a painting over a period of time lets you do things with overpainting; for instance, there are a lot of blues that I over-painted with other colors to enrich them. The oranges and russets have complementary colors underneath them to make them a little stronger. Often I'll start a painting just by working it out in one or two colors, perhaps a navy blue and burnt sienna, underpainting to a certain point and then adding colors gradually.

NEAR IVY
1982, oil on canvas
40" x 60" (101.6 x 152.4 cm)

I wanted the tops of the tall, thin pines to articulate the sky, and their trunks to be space seen against ground that had been excavated. I played off the textures of the flowering trees against the evergeens for contrast.

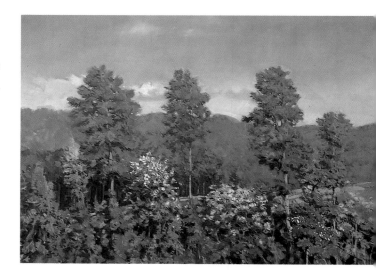

NEAR THE YELLOWSTONE RIVER
1982, oil on canvas
30" x 48" (76.2 x 121.9 cm)

This painting is a distillation of my memories of things seen on a recent trip out west. The impetus for this picture was a small painting I had done at a roadside rest stop looking up at the hills across the road. It was a good enough little painting, but when I finished it and turned around and looked at the river behind me, I realized that it was what I really should have been painting. So when I got home, I tried to do a painting from memory based on what I had seen. It probably doesn't look much like the original site, but it was enough to satisfy me.

BACKLIT PINES
1982–1983, oil on canvas
18" x 24" (45.7 x 61.0 cm)

I've returned to this idea a number of times: looking off into deep space seen through a screen of pines, and using the verticals of the trees to grid the landscape and provide reference points against a receding background.

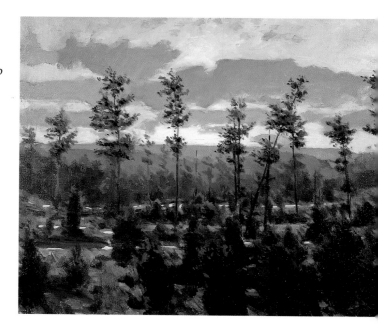

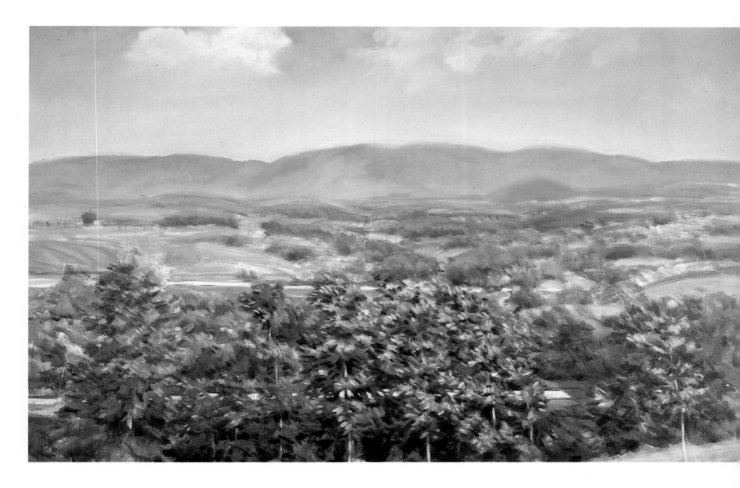

ALBEMARLE HIGHWAY
1979, oil on canvas
34" x 48" (86.4 x 121.9 cm)

This invented panorama was conceived as a view over trees and out across rolling lands to distant mountains. It has the feeling of the type of land to the north of Charlottesville, looking toward the Blue Ridge Mountains. I was trying to find the colors and textures that are indigenous to that countryside of rolling hills. The painting has the feeling of the wind blowing, of leaves turning and exposing their silvery undersides. One of the things that delighted me about this scene was the sense of something happening in the landscape.

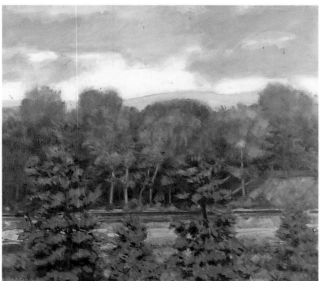

MOORMAN'S RIVER
1979–1980, oil on canvas
28" x 30" (71.1 x 76.2 cm)

Here, I was looking for a lot of grays in the trees, and looking for structure in the landscape itself.

RIVANNA BOULEVARD
1968, oil on canvas
72″ x 72″ (182.9 x 182.9 cm)

This is one of my earliest paintings. The kidney shapes were traffic islands in a boulevard in Seattle, Washington. At that time it seemed important to me to paint things that I was familiar with, that I worked with or passed by every day.

DOG IN FIELD
1968, oil on canvas
36″ x 48″ (91.4 x 121.9 cm)

At this point, I had not begun to paint outside, and this land-scape was entirely invented. I'd take certain motifs and combine them in different ways. The surface in this painting was heavily worked. I often trowelled the paint on with a palette knife. A lot of the things here have a symbolic meaning for me, but they're hard to consciously express. I know what they mean; I have feelings about them, but they're difficult to explain.

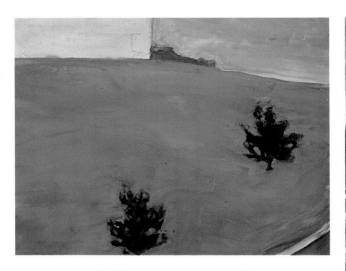

TWO TREES ON HILLSIDE
1968, oil on canvas
12″ x 14″ (30.5 x 35.6 cm)

This is a composition taken almost at random, a scattershot of geometry, and there's something quirky about it that I liked. The painting is fairly brushy, and there's a lot of paint on the surface. The paint was built up during the process of reducing the image. These early paintings are mainly about the surface and the division of the surface.

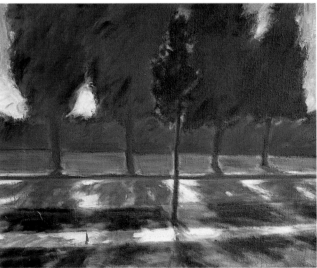

**DAVIS,
TREE AND STREET**
1972, oil on canvas
30″ x 36″ (76.2 x 91.4 cm)

When I lived in Davis, I did a lot of paintings from just walking around and then going to my studio to try to recall an impres-sion. The images were selectively chosen and usually simpli-fied. Here, I was interested in trying to get across the intense, strong light, which was something I didn't get in Seattle.

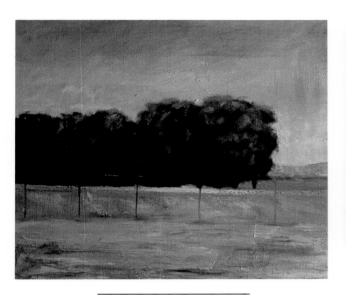

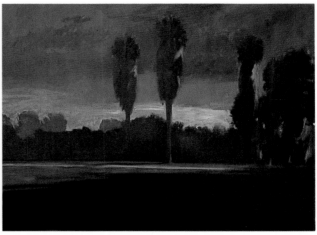

TWO PALMS, DAVIS
1974, oil on canvas
60" x 84" (152.4 x 213.4 cm)

**DAVIS NEAR
INTERSTATE 80**
1974, oil on canvas
18" x 20" (45.7 x 50.8 cm)

This small invented painting was roughly painted. The image of a row of walnut trees, going off down a secondary road, along a chainlink fence, provided me with an opportunity to make a very abstract, dramatic statement. At the time, I liked the uneasy conjunction between the skeletal fence and the dark, forbidding shapes of the trees.

This is an early studio painting that I did in graduate school. It's a large, dramatic piece, yet simple in its composition. The subject is really the mysteriousness of the palm trees: the way they seem lost, shrouded in darkness, with a spectacular sunset behind them. I wanted a warm, glowing atmosphere which would be dramatic, even to the point of being theatrical.

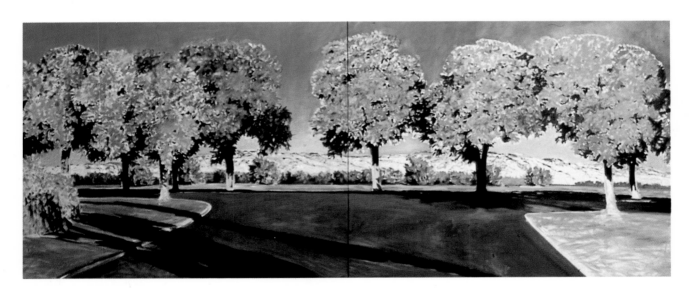

DAVIS TREES
1974, oil on canvas
60" x 120" (152.4 x 304.8 cm)

A row of planted trees along a road was the main feature in this landscape. This was painted rather thinly, and is almost a large color sketch. For that reason, it seemed to come together quickly, despite its size. I arrived at

what I wanted in terms of light and dark, and it was finished very quickly, without the reworking I had come to expect in this type of painting. I was thinking of a specific place, and that may have made the difference.

YOLO CAUSEWAY
1974, oil on canvas
30" x 40" (76.2 x 101.6 cm)

This is a view of an anonymous swampy area off of a highway. The land is so flat and bare that anything—a tree or a group of trees, or a house or a building—becomes important in the landscape. I often see little groves off on the horizon. There were no studies of this site, but I saw it every day on my way to work and back—about a ten second look each day. Eventually, this repeated impression formed a memory strong enough for me to paint from.

REFLECTIONS
1974, oil on canvas
52" x 52" (132.1 x 132.1 cm)

The series of diagonals and horizontals in this painting give it a strong geometric organization. In rendering the water, one of my concerns was to make the reflections convincing. This was an attempt to treat my experience of the Davis, California, landscape through a screen of memory.

STREET AFTER RAIN
1974, oil on canvas
30" x 36" (76.2 x 91.4 cm)

Here is a painting very much about light and atmosphere. It started out with a fairly specific place in mind, taken not from studies but from memory. The pearly white color of the sidewalk is used to parallel the horizon, creating a path in the fall landscape.

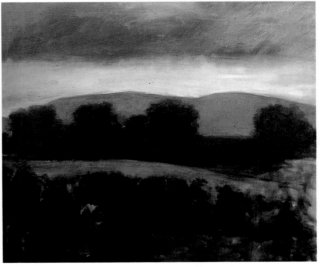

**HILLS,
ALBEMARLE COUNTY**
1975, oil on canvas
30" x 36" (76.2 x 91.4 cm)

This is probably my most abstract painting: the forms are more organic than geometric. I did a great deal of simplification in the biomorphic forms by manipulating the light. The value and color in this painting are operating as atmosphere.

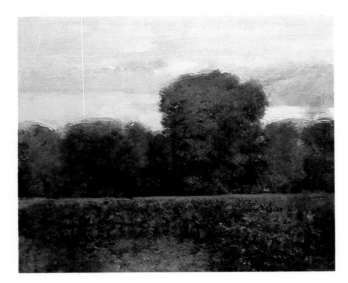

CORNFIELD
1976, oil on canvas
40" x 48" (101.6 x 121.9 cm)

I did this painting thinking about some of my drives across country, looking out at farmland in the Midwest, around Ohio. Driving along late in the afternoon, I'd see the light coming down across the tops of the cornfields, the humidity in the air was giving a blue cast to the things in the distance. This is a fairly heavy painting, but it somehow has a delicate feel to it.

JEFFERSON PARK AVENUE
1977, oil on canvas
40" x 48" (101.6 x 121.9 cm)

This painting is a treatment of a specific place, done from memory rather than actual studies. I did a lot of simplification: the interest is in the light and shadow, and the way the light makes you aware of the textures in the trees. Shadows of objects outside the frame of the painting are being projected into it, such a the telephone pole shadow that defines the hillside so crisply.

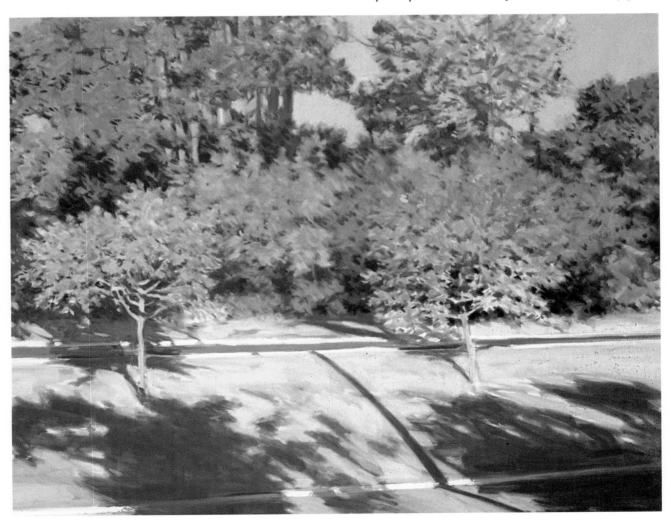

STUDIES AS REFERENCE AND PREPARATION

I will sometimes paint a cluster of studies of a particular place before I feel I have enough information to begin a large painting. A few of my more specific larger paintings are based directly on studies that were made on site. A painting about atmosphere, a certain time of day, or a certain unique formation of the landscape is more likely to lean heavily on studies.

With some of the large Virginia paintings, I'm trying to bring together many years of looking at the Virginia landscape. There are a number of things that set Virginia apart, such as the sense of space you get—there's always that feeling of being enclosed by mountains. You are often aware of the sky and the pressure of clouds coming down low over the landscape. The clouds in Virginia seem very solid to me, and in the studio paintings I try to bring them into a balance with the mountains, where they can hold their place with them.

I progress very slowly, and a studio painting takes me several months to finish. When you don't know exactly what you want, you have to keep looking for it—trying new things out, comparing, and cutting. It's all trial and error. There's quite a difference between knocking off a two-hour plein air painting and tackling a three- or four-month studio painting. In the studio, there is more room for you to navigate, to make and correct mistakes. Some studio paintings may remain in progress for several years. Sometimes I will rework or partially paint over paintings that were considered to be finished. Sometimes you can improve a painting by working over an abandoned painting, since parts of the original painting will often be assimilated into the new work.

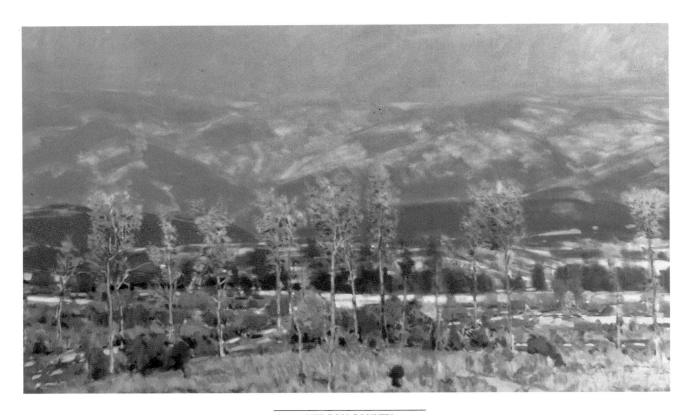

NELSON COUNTY
1985, oil on canvas
36″ x 60″ (91.4 x 152.4 cm)

This is a painting I had been wanting to do for a long time. I had a couple of small studies relating to this theme—the way the values in the distant mountains with snow on them match the color of the sky, so that snow and mountain and sky all seem to become part of the same fabric. This type of optical effect fascinates me, and I'm usually eager to do a painting about it. Here, that fabric forms a backdrop for some attenuated trees that still have some leaves with color in them.

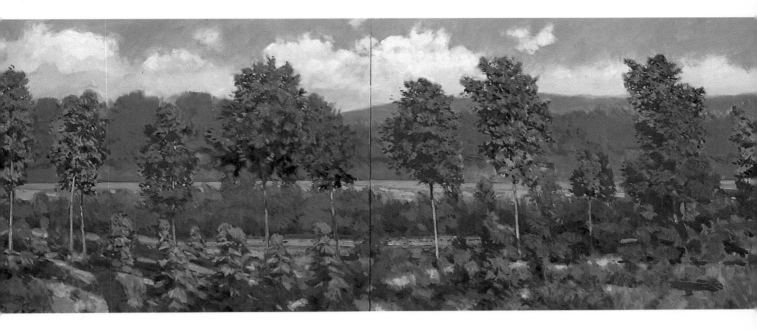

ALBEMARLE COUNTY
1982, oil on canvas, diptych
40″ x 96″ (101.6 x 243.8 cm)

Many of my larger paintings are attempts to bring together motifs that I have worked with in my smaller paintings, where I try to sum up ideas that have come from observation. Part of improvising a painting like this is trying to see to what extent I've absorbed the information in the landscape, and to what extent I can reconstitute it. This is not a real place, but an invention based on many real places; an attempt to capture the feeling of the landscape.

BACKLIGHTING, JEFFERSON PARK AVENUE
1975, oil on canvas
30″ x 40″ (76.2 x 101.6 cm)

This was painted when I was new to Virginia, and my impressions of it were strong and fresh. I was constantly comparing the new landscape with more familiar places—Hawaii, Seattle, and northern California. This painting is invented to some extent, and to some extent it's based on a real site.

EVOLUTION THROUGH SUCCESSIVE VERSIONS

A painting will emerge only after many images have been worked, defined, rejected, and replaced, and the painting is at last built up out of the ashes of different attempts. Painting for me is an organic process, an ongoing process of change like the growth of a tree, a geological formation, or the development of a person. The final painting will somehow contain all previous stages and versions. This is why some paintings are not so much finished as abandoned; otherwise, the painting could continue to evolve almost indefinitely.

Often I'll rework a large studio painting over and over again. In fact, I almost always rework my paintings. As long as I feel that there's something in a painting that I'm not sure about, I'll keep working on it. Sometimes I'll put a painting away for a long time, and it might be several months or even years where I will not work on it. I continually take my old paintings out, put them on the easel, and look at them for a while to test them. I like to see if they need changes, or if my ideas about a given painting have changed. If they have, I'll start painting into it right away, with very little ceremony.

It is difficult for me to say precisely when a painting is finished. A painting may need to be completely and thoroughly reworked, and frequently this will result in its destruction. But I think there's no harm in that—sometimes it's necessary to destroy paintings. I'd much rather do that than give up on them too easily.

A painting will sometimes return unsold from my gallery, and no painting is ever safe once it's back in the studio. It's hard to say exactly what it is that sets off the ideas for those changes: it may have been some experience I had while out driving around, or sometimes I'll see a glimpse of something that clicks into place and makes me want to work it into a painting again. In fact, this process seems to be developing into a fairly consistent working method. I start a painting with a very general idea, go through a number of changes, leave it alone for a while, and then finally I may go through three or four permutations. Usually I'm trying to get the structure clearer, to bring out a stronger composition, and to give it a more convincing sense of a place.

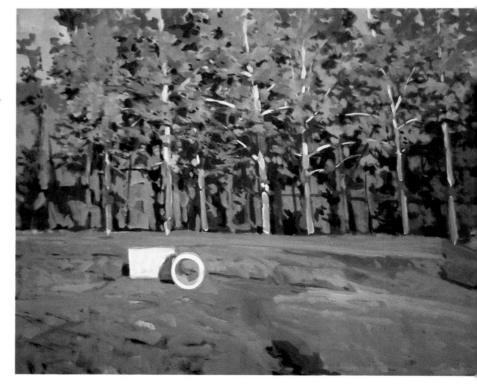

LEVELED FIELD
1986, oil on canvas
36" x 48" (91.4 x 121.9 cm)

I had seen those two pieces of culvert sitting out in the field for a long time, and this painting is a fairly direct transcription, via memory, of an actual scene. I painted it quickly, in just one or two sittings. It's a painting that has never been particularly popular, which is fine by me. It really flies in the face of the sentimental appeal of landscape, and I think it's probably unsaleable for that reason, but I like it quite a bit. There's a sense of what the land had been and what it was going to become. There is another painting under this, which was one of the reasons why it was painted so quickly: it was a question of adding to an established scheme rather than starting from scratch. Some of the structure of the previous incarnation still shows through faintly.

RAGGED MOUNTAIN
1982, oil on canvas
40" x 60" (101.6 x 152.4 cm)

I took about six inches off the upper part of this canvas after the painting was completed; this gave more importance to the mass of trees. I like the way the perspective curves around the mass of trees and disappears in the distance, off to the right side of the picture.

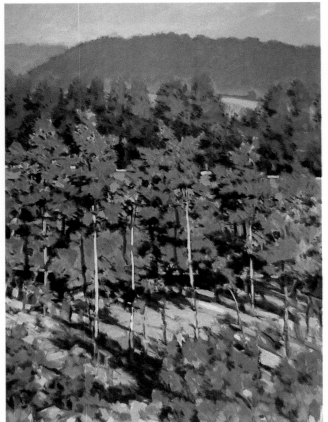

NEAR FRONT ROYAL
1984, oil on canvas
48" x 36" (121.9 x 91.4 cm)

I like the notion of looking down on the landscape with a high horizon. Sometimes a painting that dissatisfies me—as this one still does—keeps me thinking about why that is, and I will return to it eventually with the idea it needs.

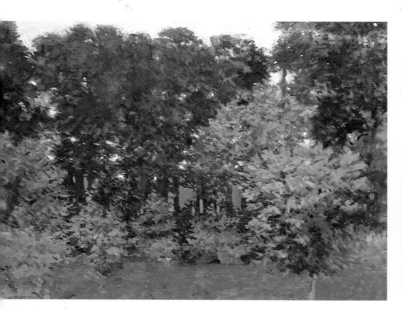

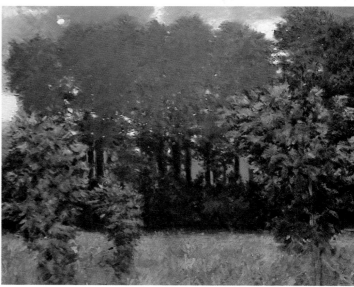

**CLEARING SKIES
(FIRST STATE)**
1975–1978, oil on canvas
36" x 42" (91.4 x 106.7 cm)

**CLEARING SKIES
(SECOND STATE)**
1975–1978, oil on canvas
36" x 42" (91.4 x 106.7 cm)

*These are three versions of the same painting, as it evolved over
a three-year period. The first one is full of detail, worked up
from observation and studies. The second painting was simpli-
fied: things were removed, the structure became more unified,
and the light became more specific, in this case, moodier. In the
final version, everything became even simpler: the landscape
opens out into a much deeper space, the color was deepened,
and the paint was thickened through the successive reworkings.
The proliferation of detail was sacrificed for a strong, simple im-
pression. This painting is a record of my working process from
the way I saw the landscape into the way I remembered it.*

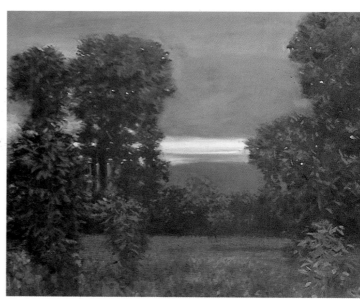

**CLEARING SKIES
(THIRD STATE)**
1975–1978, oil on canvas
36" x 42" (91.4 x 106.7 cm)

FARMLAND
1975, oil on canvas
24″ x 36″ (61.0 x 91.4 cm)

The central California valley landscape is planar, broken in places by the accents that groves of trees make. I moved trees from place to place in the interest of composition, and the proportions of the various striations of the landscape changed many times during the process of painting. I also changed the sky from dark to light and back more than once.

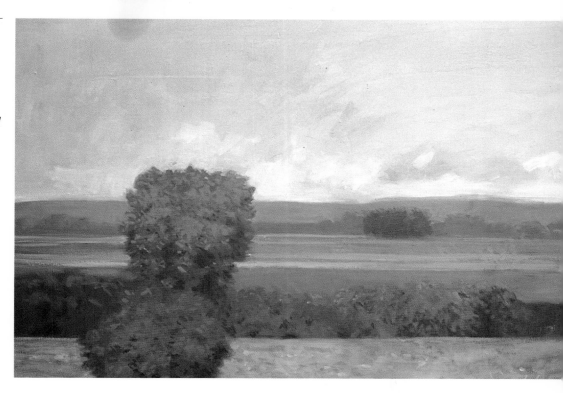

PUTAH CREEK
1974, oil on canvas
14″ x 18″ (35.6 x 45.7 cm)

I forced a simplification into this painting by using the light and shadow as an organizational system in the painting. I tried to express my feelings for a place: the warmth of the light, the atmosphere. This is a small painting; I started it on the spot and then worked it up in the studio. The time in the studio has a lot to do with the elimination of the things that are no longer important to the picture, the superfluous details.

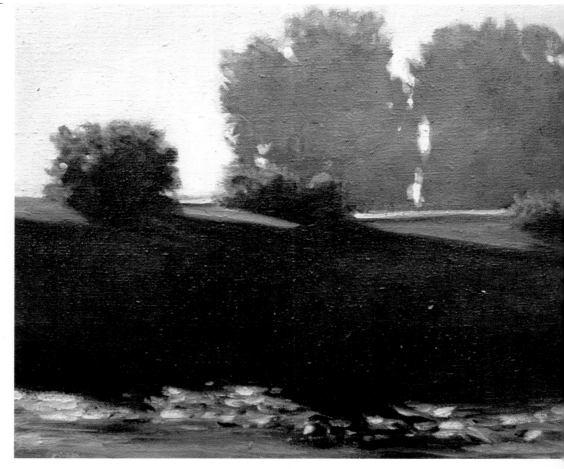

CONVINCING INVENTION

Whenever you paint outside, the value of the experience is not so much in getting little paintings you can take back to the studio, but in forcing yourself to look carefully at what you're painting. You can retain a lot of that information, and it can serve as a kind of library of the possibilities of the landscape—images that can be drawn on later. The more painting outside you do, the more readily those images will come to you in the studio. You will begin to synthesize the general sense of a familiar place, out of a longstanding familiarity with its motifs. It takes a long time to get to the point where you can call up images of a particular area from your mind at will. In some of my most recent Virginia paintings, there's an attempt to do just that; I'm trying to sum up many years of painting outside.

Constructing a convincing painting has a lot to do with the way you interact with the paint. As you start putting marks down on the canvas, you begin to understand them as features of a landscape: a brushstroke can become a tree, or an unintended mark on the canvas can, instead of being a mistake, suggest another feature of the landscape. The painting evolves and grows organically, like the landscape itself.

A test I give myself is to look at a painting I feel is finished and see if it convinces me. Can I imagine walking through the space of this painting? I also look for colors and tonalities that are believable—whether or not they're exactly natural. Colors are going to be believable if they are consistent, and if the painter is sure of them.

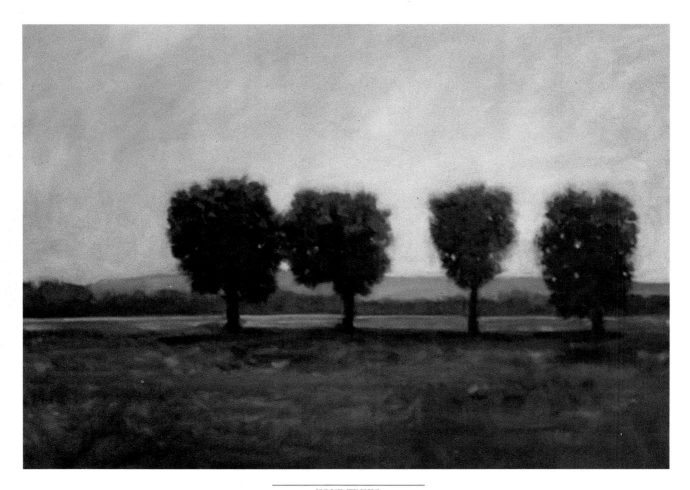

FOUR TREES
1974, oil on canvas
30″ x 40″ (76.2 x 101.6 cm)

In this invented scene, my focus was to line the trees so that they would give a visual rhythm to this simply organized picture. I tried to give the trees a solidity, a place in the landscape that I hoped would feel right. At this stage, I was beginning to learn how to make invented forms appear real.

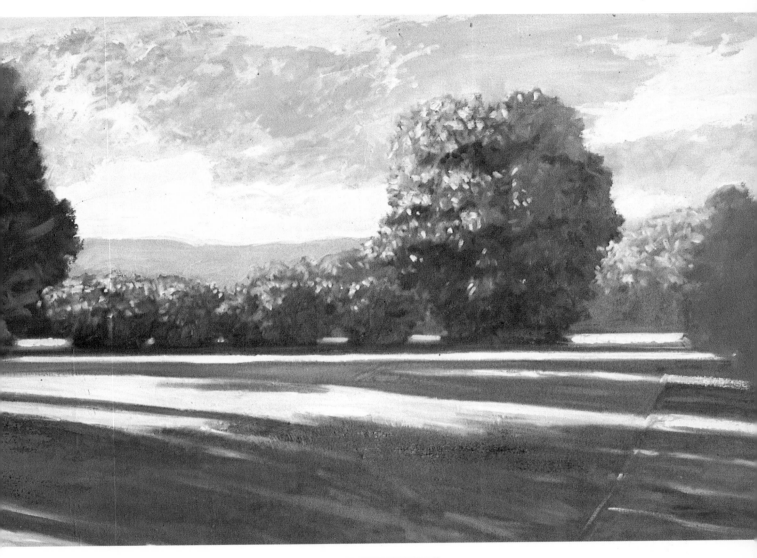

**TOWARD THE
COAST RANGE**
1973, oil on canvas
26" x 36" (66.0 x 91.4 cm)

*This was a transitional painting for me. I had done plenty of
plein air painting by this time, and it shows in the elements. I ar-
ticulated the sky with a lot more attention to making realistic tree
textures, and I tried to get the proper color for the shadows more
than in my previous paintings. There is a simple organization
of space, but I attempted to make the landscape as convincing
as an actual scene.*

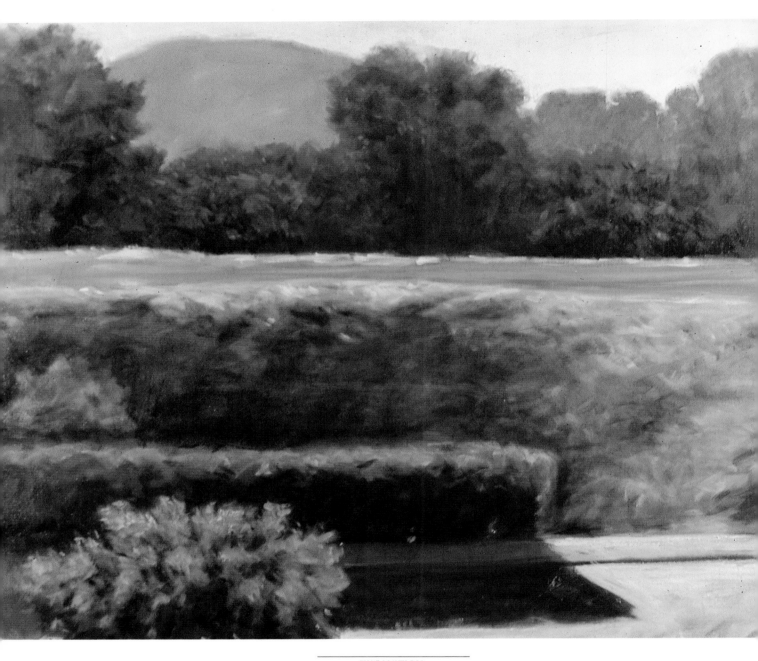

**EXCAVATION,
JEFFERSON PARK AVENUE**
1975, oil on canvas
40″ x 48″ (101.6 x 121.9 cm)

In viewing this painting, your eye will start with the tree that is cropped by the lower left edge of the canvas, and work back through the landscape, crossing a series of barriers. There are faint diagonals that pull you back, but generally the space is made up of an atmospheric perspective, a lessening of intensities and textures. Often in the process of painting, I try to put myself in the picture, asking myself how I would move through its space.

SEATTLE NEIGHBORHOOD
1971, oil on canvas
30" x 38" (76.2 x 96.5 cm)

Although I based this painting on actual places, some of the things were changed and simplified; the bush is no longer a specific bush, but becomes more of an archetypal shrub. I was picking up on different elements in the landscape that could be made into compositional elements—inclines, ramps, rooftops, and so forth.

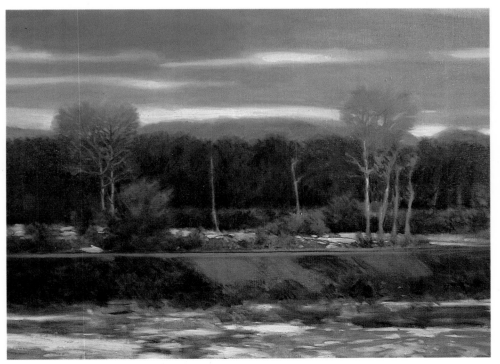

TRACKS NEAR IVY, SNOW
1977, oil on canvas
30" x 36" (76.2 x 91.4 cm)

I feel this is a convincing invention; it is entirely made up. I like the different levels of the composition, the heights and depths of the ground plane that work as barriers in the picture. The painting itself, the composition of a rectangle within a rectangle is an area of framed space. This has that static, timeless, or dreamlike quality that I really like in paintings.

THE FIGURE IN THE LANDSCAPE

As an undergraduate I took the usual life drawing and life painting classes, and models were readily available; at that point, being a landscape painter hadn't even occurred to me. Once I was out of school, however, models were no longer easily available. As anyone who has tried will know, you can get a friend to come over and pose for you once, but he or she is not liable to keep still or to come back. Also, in some of the figure paintings, I found myself more interested in the background, in the landscape I could see out the window, than I was in the figure. I started working more with landscape for those reasons, and also because I was feeling uncomfortable about the narrative quality that begins to creep into a painting any time the figure is present—*Why is the figure there? Why is the figure doing this?* There is a tendency to start inventing little stories about the people depicted, which, to me, detracts from the painting as a painting.

In graduate school I would often try to integrate the figure into a landscape, and during this period I used photographic sources, always very loosely. When I moved to Virginia, I effectively gave up using the figure. There were a few paintings where figures existed—along with whatever else happened to be part of a site when I was painting there. When people got in my way, I painted them.

In the last year or so I've come to the conclusion that my paintings really are, in a way, figurative. That is, they always talk about a human presence in the landscape; mainly because it's not easy to find a landscape without people, or the evidence of people, in it. For these reasons, I decided to bring the figure back into my work. It was a struggle for me, and I don't feel I've been entirely successful, but I'm making progress.

When I painted on site at Mount Holyoke in Massachusetts, and Mount Battie in Camden, Maine, I was essentially a tourist among tourists, so it seemed natural to paint the people who were out looking at the view, picnicking, or playing. Also, watching Philip Geiger (a landscape and figure painter who also lives in Charlottesville) paint has had an influence on me, especially the ways in which he manages to avoid the narrative, or at least avoids making the narrative a specific element of his painting.

The flower paintings, in an odd way, also led to the figures. In those small paintings the individual flower is treated as a subject with the central importance of a figure. Where my earlier landscapes may have had no identifiable subjects at all, in the flower paintings there is a direct, simple approach to the subject, which I like. This is something I hope I can maintain in the figurative paintings. I want them to be landscapes where there just happens to be a figure.

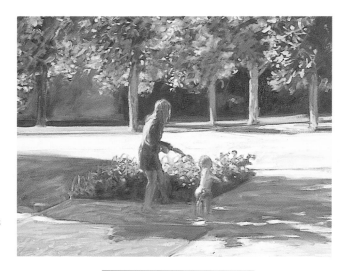

GARDENING, DAVIS
1979, oil on canvas
24″ x 30″ (61.0 x 76.2 cm)

In this painting I consulted photographs in painting the figures, mostly for the lighting and for the pose. I used light to simplify the figures and to clarify the structure of the painting; the large shadow coming in from the left-hand side of the picture is the major articulation of the space in which the figures sit.

CAT SITTING ON MY RADIATOR LOOKING OUT THE WINDOW
1972–1973, oil on canvas
9″ x 12″ (22.9 x 30.5 cm)

This cat used to visit me, so it was an obvious choice for a model. She looked like she would make a good still life.

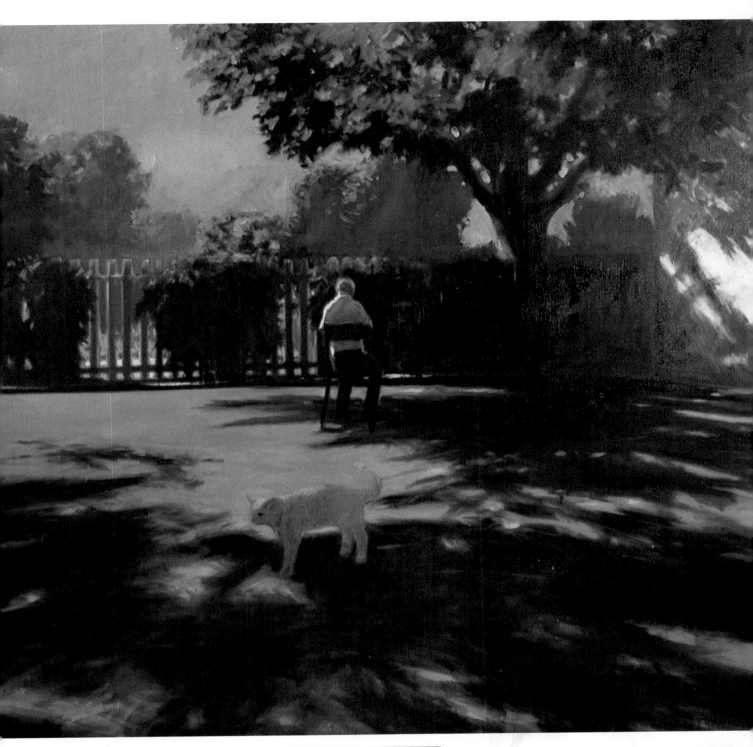

BACKYARD WITH CAT
1974, oil on canvas
60" x 60" (152.4 x 152.4 cm)

I was attempting to place figures on a broad ground plane in this painting. Many of the elements from my more symbolic, earlier paintings are present here: the animal, fence, house, tree, and figure. Photographic sources were not used for this painting. My concern was with trying to make the space from the viewer to the figure in the background as convincing as possible, through a change in scale of the shadows.

PUTTING IT ALL TOGETHER

Making a large studio painting involves taking everything you know and putting it all together in some new and exciting way. In a big, ambitious painting your complete personal history, your entire vocabulary of images, is on call. Every place you've been, everyone you've known, everything you've seen is available to influence what is happening in the painting.

The sources of my paintings are not always entirely conscious, since for the most part I work intuitively. When I'm standing in front of the canvas with a brush in my hand, I'm not thinking about why I'm doing what I do, but simply doing it. There are times, of course, when I'll sit for an hour and just look at the painting. Those are the times when I might get very

analytical, thinking things like, "I'd better move that hand," or "I should put a tree in here to complete the movement through the picture." I'll try to see what it is I've done and then capitalize on the directions that seem to work the best.

It's a process of trying to bring together the many elements of imagined or real experience, memory, and structure. I try to get all of these things onto the canvas at one time and into a balance that makes for a satisfying whole. In the long run the invented paintings are more important to me, because I have more of myself invested in them. I can always go out and paint a plein air painting and make something happen on a canvas by looking at the landscape. With my studio paintings it's

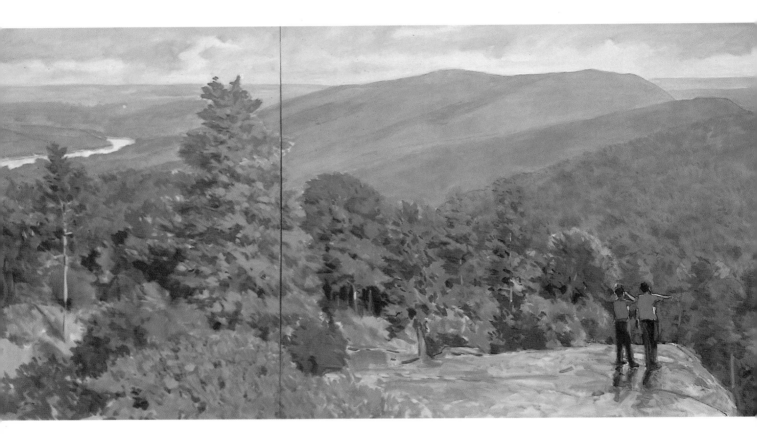

more of a struggle, and I never know what's going to happen. It all depends on what I can realize out of a painting.

In the studio it's always hit-or-miss and very experimental; most of my paintings will die and get resurrected two or three times in the course of being painted. Because the notion of a finished painting is alien to my intuitive way of working, my paintings often continue to evolve if I get my hands on them again, even after they've been exhibited.

The paintings I'm doing today are not overtly symbolical or emotionally charged, but they do have meaning for me beyond the simple idea of the painted picture of a landscape. They reflect the many places I've been over the course of my life, perhaps in ways that are not accessible to anyone but me. The paintings are not symbolic in any narrative way, but rather stand for a state of mind, or a specific metaphorical feeling.

I paint because painting is exciting, and because I love doing it. If my paintings work, it's because I have thought of them primarily as paintings. I'm not trying to tell a story, or trying to make a painting *about* a place or *about* a thing; I'm only trying to make a painting. When I work in the studio, the formal aspects of painting become extremely important, and I make conscious judgments about composition, color, and space; but in doing so I always strive to balance that formalism against the always very intuitive act of painting itself.

KINDRED SPIRITS
1987, oil on canvas, triptych
42¼" x 140" (107.3 x 355.6 cm)

The large middle panel is the main piece, with two subordinate side panels. This painting has an allusion outside of the painting itself, which is a little unusual for me. It refers to two different paintings: The Oxbow, *painted by Thomas Cole in the 1830s from Mount Holyoke, which is indeed part of what you see in the right-hand panel, and I took the title,* Kindred Spirits, *from a painting by Asher B. Durand as an homage to Cole. This was painted from the same vantage point that Cole used to paint his picture. My "kindred spirits" are just two ordinary people who are looking at the landscape on top of Mount Holyoke. I was after the same grandeur and sublimity that Cole and Durand were looking for, adding my own sense of the importance of the ordinary in the scheme of things.*

In these more ambitious figure paintings, I'm using elements that I've had in my work for some time, but I'm pulling them together into an attempt at a more important statement. It feels like the last ten years or so have been a period of learning for me: I've done a lot of painting outside, and have been looking carefully at all kinds of things. There's obviously a lot more I need to work on—I need to work on figures, but it feels like the right thing to do. I was worried about the introduction of figures before this point, because of the narrative aspect which always attaches itself to the human figure, but now I seem to be able to introduce an obvious human presence into the pictures without bringing up that problem.

MPB IN MAINE
1987, oil on rag board
10" x 15" (25.4 x 38.1 cm)

This little study of a figure in a spring landscape was one of my first intimations of the idea that was to become the large triptych, Gardening in Maine. *The interest here is in the light on the figure—I'm not trying to paint a portrait at all, simply an evocative figure for scale and light. As it stands, it is, oddly enough, a recognizable portrait of my wife, but I think that comes from the pose, the clothing, and the proportions, rather than from any particular intention of mine.*

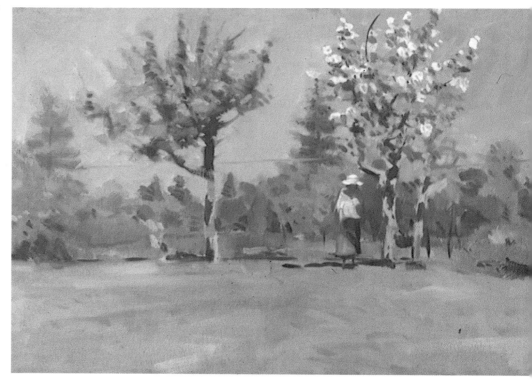

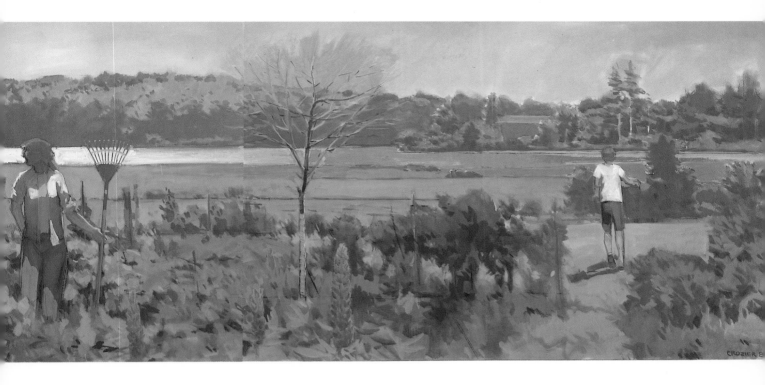

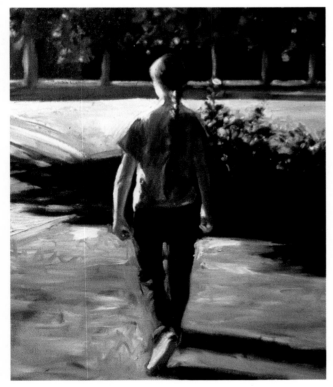

GARDENING IN MAINE
1987, oil on canvas
40" x 180" (101.6 x 457.2 cm)

This is perhaps my most ambitious painting to date. I was interested in making each of the panels function separately and work together as a whole. The flowers in the foreground were an outgrowth of my small flower studies that I'd been doing, and also an opportunity to play with the sense of scale and the point-of-view over a broad, inclusive space: for instance, measured as marks on the surface of the canvas, the flowers are the same size as the figures.

The landscape is based loosely on the bit of land I lived on for a couple of weeks in Maine, but there have been major changes: the land had been reshaped at will, and the gardens and plants were invented. I also made some deliberate distortions in this painting. It's really not possible to see foreground, middle ground, and the range of distances all at once; I have several different scale systems and vanishing points in operation here. Because of this, you first focus on the man in the garden in the first panel then you shift to the woman with the rake, and finally you see the boy running. By controlling and directing the movement of the viewer's eye, I was able to introduce the dimension of time into a static medium.

RUNNER
1975, oil on canvas
14" x 12" (35.6 x 30.5 cm)

INDEX